Raphael

Stephanie Buck
Peter Hohenstatt

Raffaello Santi, known as
Raphael

1483–1520

h.f.ullmann

Frontispiece
Sistine Madonna
(detail ill. 103)

Front cover
The Triumph of Galatea
(detail ill. 76)
© Photo Scala, Florence

Back cover
Portrait of Maddalena Doni
(ill. 27)
© Scala / Ministero per i Beni e le Attività Culturali

Quotation (back cover)
Pandolfo Pico della Mirandola to Duchess Isabella Gonzaga of Mantua on Raphael, 1521

© 2007 Tandem Verlag GmbH
h.f.ullmann is an imprint of Tandem Verlag GmbH
Special edition

Art Director: Peter Feierabend
Project Manager and Editor: Sally Bald
Assistant: Susanne Hergarden
German Editor: Ute E. Hammer
Assistant: Jeannette Fentroß
Layout: Claudia Faber
Cover Design: Simone Sticker

Original title: *Meister der italienischen Kunst - Raffael*
ISBN 978-3-8331-3797-6

© 2007 for the English edition: Tandem Verlag GmbH
h.f.ullmann is an imprint of Tandem Verlag GmbH

Translation from the German: Christine Varley and Anthony Vivis
Contributing Editor: Chris Murray

Printed in China

ISBN 978-3-8331-3798-3

10 9 8 7 6 5 4 3 2 1
X IX VIII VII VI V IV III II I

Contents

2 Study for the *Baronci Altarpiece,* ca. 1500/01
Black chalk and metal point, squared, 39.4 x 24.8 cm
Musée des Beaux-Arts, Cabinet des Dessins, Inv. Pl. 474,
Lille

This is the original design for Raphael's first documented altarpiece, only fragments of which now remain. Up above, the Virgin Mary, God the Father, and St. Augustine are crowning St. Nicholas of Tolentino, who stands below, trampling on the Devil. The models for the figures were the *garzone,* young apprentices, who in this study have been drawn wearing everyday Florentine dress.

When Raphael died at the age of 37, on Good Friday, 1520, even the Pope wept. We learn of this extraordinary reaction in Giorgio Vasari's "Lives of the Most Excellent Architects, Sculptors and Painters," published in 1550, in which Vasari calls Raphael a "mortal god." Raphael of Urbino achieved everything an Italian Renaissance artist could hope to accomplish: the artist most in demand for the decoration of the Vatican, where he created monumental fresco cycles, he also painted altarpieces, devotional images and portraits for many of the most important Italian dignitaries of his age, some of whom were the greatest art patrons in Europe; and, as chief architect, he supervised the construction of St. Peter's in Rome, the most important building project in Christendom. In addition, he undertook to list and preserve the ancient monuments of Rome, for he can be credited as the one of the very earliest of the modern conservators of ancient monuments.

Raphael's meteoric career first began not in Rome but in Urbino. It was an ideal setting in which to distinguish himself. He was born there on Good Friday 6 April 1483, the son of Màgia di Battista di Nicola Ciarla and Giovanni Santi di Pietro. His father was a painter and poet at the court of Federico da Montefeltre, one of the most famous princes and art patrons of Early Renaissance Italy. When the Duke died in 1482 he was succeeded by his son, Guidobaldo, under whom Giovanni Santi continued to enjoy a steadily increasing reputation as court painter until his death in 1494. According to Vasari, Raphael's father was not an outstanding painter, though he was a "man of good sense." Vasari also claims that Raphael started helping out in Santi's studio at a very early age. Though Vasari's account tends to be episodic, so that the documentary value of his "Lives" is sometimes questionable, it is reasonable to assume that Raphael did in fact learn the fundamentals of art in his father's studio. This assumption is supported by the fact that his first recorded commission – for an altarpiece in 1500 – mentions that his collaborator was Evangelista da Pian di Meleto, who in 1483 was a *famulus* (assistant) in Santi's studio. Evangelista is also recorded as being one of the witnesses when Giovanni Santi's will was read on 29 July 1494.

What is still unclear is where Raphael received his training after this early period in his father's workshop. According to Vasari, Giovanni Santi apprenticed his gifted son to Pietro Perugino. However, there is evidence from several sources to show that Raphael remained in Urbino until 1499, a period during which Perugino was managing a workshop in Perugia, as well as carrying out commissions in Florence and Rome. By 1500, Raphael, now seventeen, was presumably no longer an assistant. The contract mentioned above, for an altarpiece in Andrea Baronci's chapel in the church of Sant'Agostino in Città di Castello, a small town near Urbino, is dated 10 December 1500. Here Raphael is already described as a *magister,* a "master." Furthermore, stylistic comparisons which have tried to find signs of Raphael's hand in Perugino's works remain inconclusive. It is not until we reach the period around 1502/03 onwards that Raphael's works – such as the London *Crucifixion* (ill. 6) – show clear links with Perugino. It therefore seems reasonable to assume that Raphael's association with Perugino did not begin until after 1500.

In comparison with other early works by Raphael, we are well informed about the *Baronci Altarpiece* (ills. 2 – 4), since we have not only the contract but also a record of payment, dated 13 September 1501. The altarpiece is dedicated to Nicholas of Tolentino, a 13th-century Augustinian hermit who was not canonized until 1446, though his cult reached an early highpoint of popularity, especially in Città di Castello, around 1500. The altarpiece was badly damaged in an earthquake in 1789, and from 1849 onwards the surviving sections have been kept in various collections. Raphael's preparatory drawing (ill. 2) gives us a general idea of the whole composition, divided horizontally into two zones. Raphael repeatedly returned to this form of pictorial structure – the *Madonna di Foligno* (ill. 102), for example, painted while he was in Rome, is just one of several later versions. In this early altarpiece the figures are still rather isolated: pictorial space as a continuous entity is not yet a subject in its own right.

The two surviving fragments of angels, however, already reveal Raphael's ability to depict his figures' psychological states. The Paris angel (ill. 3) is quite clearly meant to look deeply moved. Unexpectedly

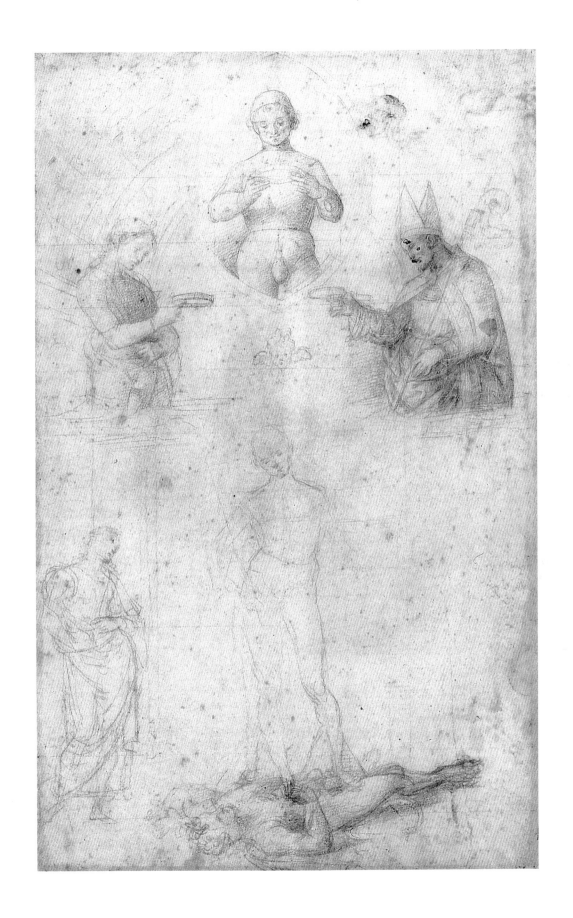

3 (left) *Angel* (fragment of the *Baronci Altarpiece*),
ca. 1500/01
Panel, 57 x 36 cm
Musée du Louvre, Paris

The French curator Sylvie Béguin published details of this
angel fragment from the *Baronci Altarpiece* after it was
bought by the Louvre in 1981. According to Raphael's
preliminary study (ill. 2) the figure stood on the lower
left, next to St. Nicholas of Tolentino. The powerful
modelling of the angel's head, and the emphatic
expression on his face as he gazes upwards, indicate that it
is an early work by Raphael.

foreshortened, the angel's powerful head is staring
upwards. His eyeballs are projecting, his hair is flying
behind him, his lips are reverently parted. By contrast,
the Brescia angel (ill. 4) seems much gentler. In the very
modelling of the features there is a softness in the light
and shade that is entirely in keeping with this angel's
nature. It is clear that Raphael meant to emphasize the
contrast between these two figures. This ability to
convey a range of psychological subtleties in visual terms
was something quite new in Umbrian painting.

After the *Baronci Altarpiece*, Raphael painted a
number of pictures that confirm the popular view of
him as the painter of charming Madonnas. The

Pasadena *Madonna and Child* (ill. 22) is a good example
of these works, all of which show half-length figures seen
from close up. We do not know who commissioned
them, though their small scale suggests they were meant
for private devotion. The subject is the familiar one of
Mother and Child reflecting on the Passion and calmly
accepting their predestined fate. The figure types are
derived from Perugino's studio: in the Madonna we see
the same finely proportioned oval face with a small,
cherry-shaped mouth, and in the Christ Child the
same swollen belly of an infant and shoulders that are
proportionally much too narrow. The figures in these
early Raphael paintings, though, are closely in contact

4 (above) *Angel* (fragment of the *Baronci Altarpiece*),
ca. 1500/01
Panel, 31 x 27 cm
Pinacoteca Civica Tosio Martinengo, Brescia

The study for the *Baronci Altarpiece* (ill. 2) shows only a
single angel, but a partial copy of the altarpiece from the
18th century in Città di Castello, and a description
written in 1789, prove that pairs of angels stood on either
side of the main figure. The angel shown here was on the
right and was not looking at the saint in the center, but at
a figure on the edge of the picture.

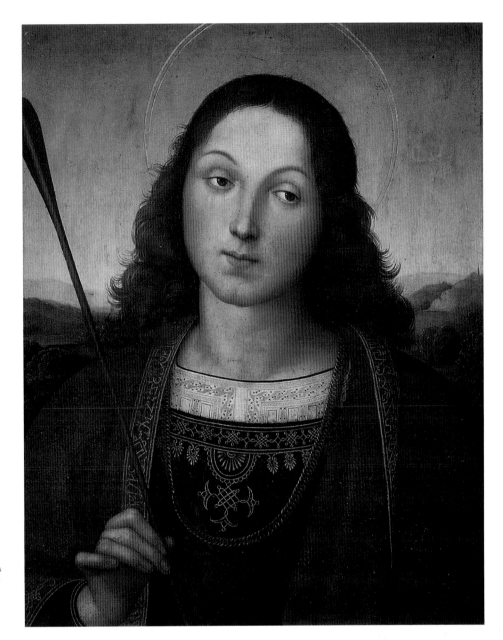

5 *St. Sebastian*, ca. 1502/03
Panel, 43 x 34 cm
Pinacoteca dell'Accademia Carrara, Bergamo

Sebastian is holding an arrow, the symbol of his
martyrdom, his little finger held up elegantly. Wearing a
gorgeous red cloak and a gold embroidered shirt, with his
hair elegantly arranged, there is nothing about this figure
that recalls the torments St. Sebastian suffered for his
faith. This is a typical early work of Raphael and, in its
ornamental beauty and elegiac mood, it is very
reminiscent of the works of Perugino.

with one another through looks and gesture. The
interest of both the figures and of the viewer is always
clearly focused on the picture's central subject.

All Raphael's surviving works from the years 1502 to
1504 show how close his relationship with Perugino
was. This is not surprising, since Perugino was one of
the most famous artists of the period and was greatly
in demand. Patrons commissioning paintings from
Raphael – who, though already a gifted artist, was barely
twenty years old – probably preferred him to paint in
the style of the well-established older artist. Occasionally,
indeed, patrons would demand repetitions of a
successful composition. In 1505, for example, the Poor

Clares at Monteluce commissioned Raphael to paint a
Coronation of the Virgin Mary which was to be based
closely on Domenico Ghirlandaio's altarpiece in the
church of San Girolamo, in Narni. In Raphael's day,
unlike our own, imitation was not scorned; Vasari
commented approvingly that Raphael, after studying
Perugino's paintings closely, "emulated them so exactly
and so completely that his copies could not be
distinguished from the master's originals." What is
striking, however, is that Raphael, having studied this
influential forebear attentively, was then able to free
himself of the influence in order to develop his own
artistic objectives more single-mindedly. These objectives

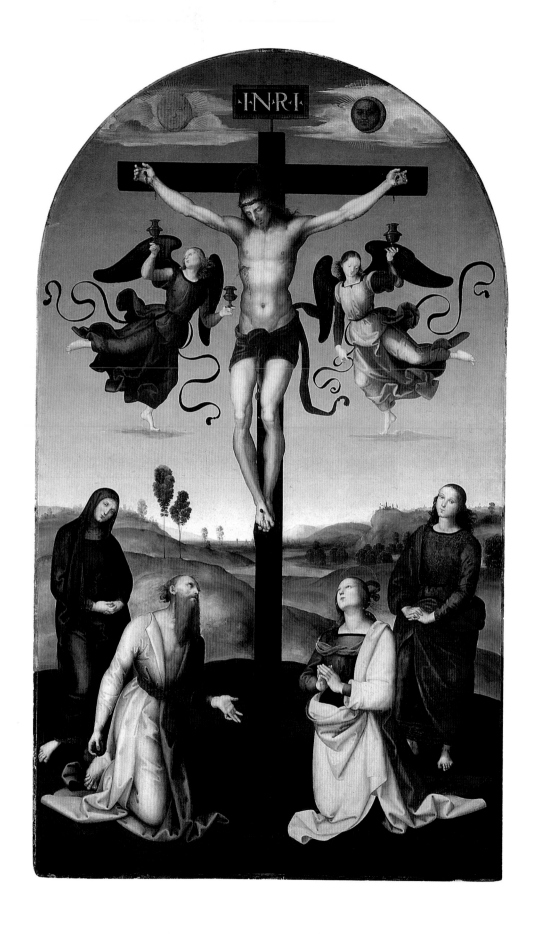

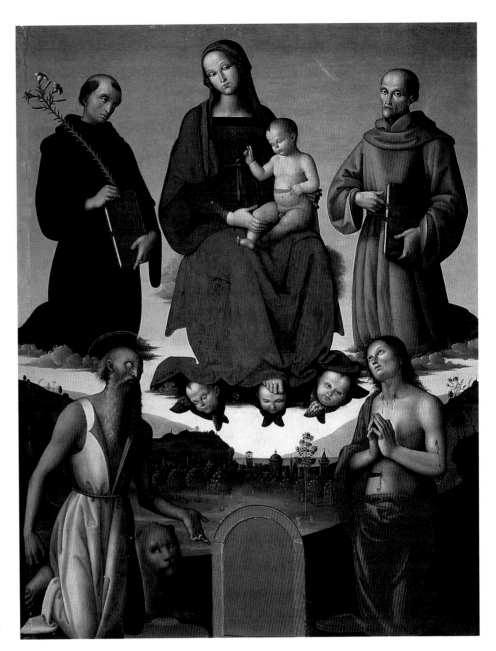

7 (right) Pietro Perugino and Eusebio da San Giorgio
Madonna and Child with Four Saints (Tezi Altarpiece),
1500
Panel, 182 x 158 cm
Galleria Nazionale dell'Umbria, Perugia

This altarpiece was intended for the chapel of Angelo Tezi
in the church of Sant'Agostino in Perugia. The Virgin is
enthroned on clouds with the Christ Child, whose right
hand is raised in blessing. On the Virgin's right is the
Augustinian hermit Nicholas of Tolentino, and on her left
is the Franciscan monk St. Bernard of Siena. Kneeling in
adoration below are St. Sebastian and, on the left, St.
Jerome, a figure very similar to the St. Jerome in Raphael's
London *Crucifixion* (ill. 6).

6 (opposite) *Crucifixion,* ca. 1502/03
Panel, 281 x 165 cm
The National Gallery, London

In contrast to the traditional format, here St. Jerome is
depicted kneeling at the foot of the Cross and in a
prominent position. Raphael has put Jerome, the penitent
Church Father who died AD 419/420, with those who
witnessed the Crucifixion: the Virgin and St. John, who
are in the background, and Mary Magdalene, who is
kneeling on the right at the front. St. Jerome is there
because he is the patron saint of the church whose altar
this Crucifixion decorated.

included setting anatomically correct figures in an
accurately depicted space constructed according to the
principles of central perspective; creating fully-rounded,
solid-seeming bodies in their full three-dimensionality;
and matching gesture and facial expression so exactly
that they seem to be integral elements of the com-
position. A study of Raphael's works shows him making
progress towards all of these artistic goals.

The London *Crucifixion* (ill. 6) stands at the very
beginning of this process. Revealingly, so Vasari informs
us, people would take the work to be by Perugino, not
Raphael – "if his name were not written on it." The date

of 1503 is on the original stone frame, which is still kept
in the place for which the picture was originally
intended, San Domenico in Città di Castello, and which
now contains a copy of the painting. The frame also
mentions Domenico Tommaso de' Gavari, who com-
missioned the picture. Raphael has immortalized
himself within the picure: RAPHAEL/URBIN/AS/P
[inxit] is inscribed on the stem of the Cross:"Raphael of
Urbino painted it." Like Perugino, Raphael does not
depict physical agony: the saints stand there mourning
meditatively, communicating a sorrow the viewer is
meant to share.

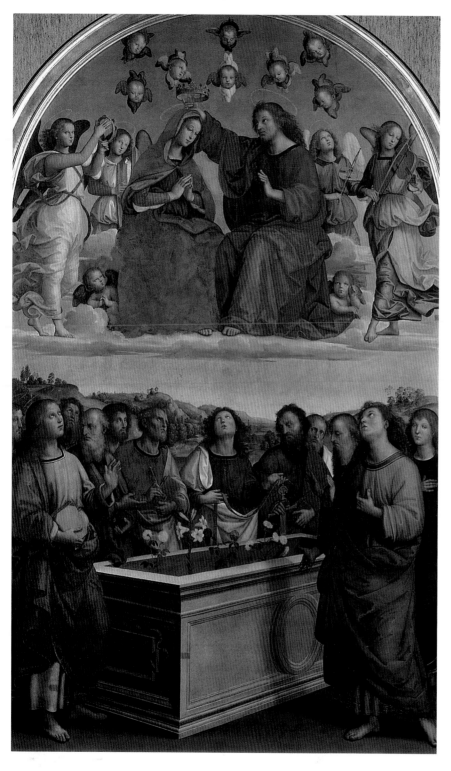

8 *Coronation of the Virgin,* ca. 1503/04
Panel transferred to canvas, 267 x 163 cm
Vaticano, Pinacoteca Apostolica Vaticana, Rome

Raphael combined several themes in this composition. The sarcophagus from which flowers are blooming is a symbol of the Assumption of the Virgin. The upper half of the picture shows the Coronation of the Virgin by Christ, and in the lower half the theme of the so-called Gift of the Girdle is illustrated – St. Thomas, the central figure in the group of the Apostles, is holding the Virgin's girdle, which she has dropped on her way to heaven.

This devout silence finds formal expression in a compositional form already prefigured in Perugino's contemporary altarpiece for San Francesco al Monte, a work now in the Galleria Nazionale in Perugia. Perugino's altarpiece is set out like a *Sacra Conversazione,* with four saints standing beside a centrally placed Cross. In contrast, the angels in Raphael's version, who in fluttering garments are dancing on tip-toe as they catch Christ's blood, are exactly like those in the *Crucifixion* in Sant'Agostino in Siena, on which Perugino was working in 1502/03. In other words, Raphael combined motifs from several different works by Perugino. Similarly, in the London *Crucifixion,* he based the figure of St. Jerome on another model from Perugino's workshop. In the main panel of the *Tezi Altarpiece,* the *Madonna and Child with Four Saints* (ill. 7), painted for the church of Sant'Agostino in Perugia in 1500 (which Eusebio da San Giorgio probably completed to Perugino's design), there is a penitent St. Jerome who is kneeling in exactly the same way in the left foreground. At first sight the figures look identical, but Raphael has intensified the expression of fervent reverence. The head in profile, is thrown back, and the left arm is more clearly foreshortened, which makes it more spatially vivid and gives his gesture of reverence greater emphasis. Also, a part of his garment is draped over his left leg, producing a greater sense of three-dimensionality.

These developments are taken a step further in the *Coronation of the Virgin* (ill. 8), which, according to Vasari, Maddalena Oddi commissioned for the family funerary chapel in the church of San Francesco, in Perugia. The probable date for the commission is 1503.

Here Raphael solves the problem of pictorial space in the lower section by placing a stone sarcophagus end-on, and standing the figures of the Apostles around it. Almost all of them are gazing up in amazement at the scene of the Virgin's Coronation, so that their intensely characterized faces can be shown, from below, in a range that clearly exemplifies the Renaissance concept of *varietà.* Compared with the angels of the *Baronci Altarpiece* in the Louvre, the Apostles' faces here are even more strongly and emphatically shadowed. Light falls uniformly from the right, so that the Apostle in the right foreground casts a dramatic shadow across the sarcophagus. It is this sarcophagus that determines the depth of this lower pictorial zone. The landscape, rather than being integrated into the composition, is spread out behind the figures like a beautiful tapestry. Discontinuity is again the keynote of the overall composition, which is once more divided horizontally into two sections.

Raphael's exceptional skill in depicting traditional subjects in a new way is especially evident in the predella panels of the *Coronation of the Virgin* (ills. 9–11). Because of a predella's subordinate position in an altarpiece, its panels allowed artists more scope for experiment. In the *Adoration of the Magi* (ill. 10), Raphael for the first time employed a compositional principle that was to serve him well many times later when he wished to organize several figures in a lively manner within a confined space. The principle was to

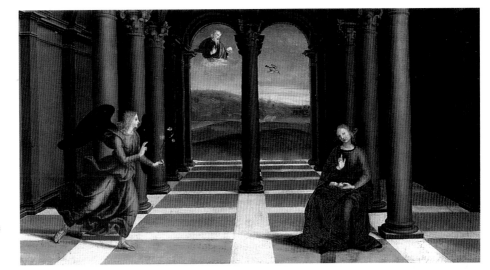

9 *The Annunciation* (from the predella of the *Coronation of the Virgin*), ca. 1503/04
Panel transferred to canvas, 27 x 50 cm
Vaticano, Pinacoteca Apostolica Vaticana, Rome

In a vast and empty loggia, the Angel Gabriel is announcing the birth of Christ to the Virgin. The angel has entered taking great strides, but he is waiting in front of the left row of columns while the Virgin calmly receives his message without rising from her seat. God the Father floats on a cloud in heaven and sends down the Holy Ghost in the form of a dove.

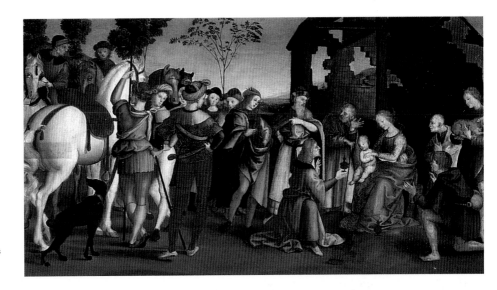

10 *Adoration of the Magi* (from the predella of the *Coronation of the Virgin*), ca. 1503/04
Panel transferred to canvas, 27 x 50 cm
Vaticano, Pinacoteca Apostolica Vaticana, Rome

The Three Kings arrive with a great retinue to pay homage to the Christ Child with precious gifts. The shepherds, too, who were the first to worship Him, are still standing around the Virgin at a respectful distance. Raphael shows the very different animals that the visitors have brought with them: an aristocratic greyhound on one side, a sheep on the other.

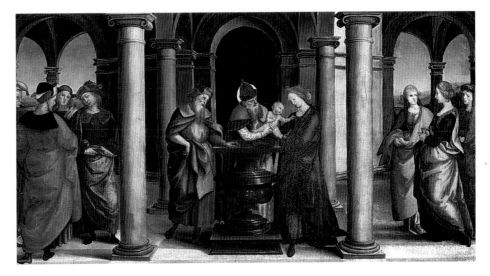

11 *Presentation in the Temple,* (from the predella of the *Coronation of the Virgin*), ca. 1503/04
Panel transferred to canvas, 27 x 50 cm
Vaticano, Pinacoteca Apostolica Vaticana, Rome

This version of the Presentation in the Temple, an important event in the history of the childhood of Jesus, sets the scene in an arcade in front of the temple. The Virgin is holding up her Son towards the aged Simeon and the Child is struggling and turning back to his Mother. Joseph is standing on the left watching the scene, while a maid on the far right is holding two doves in readiness as a sacrifice.

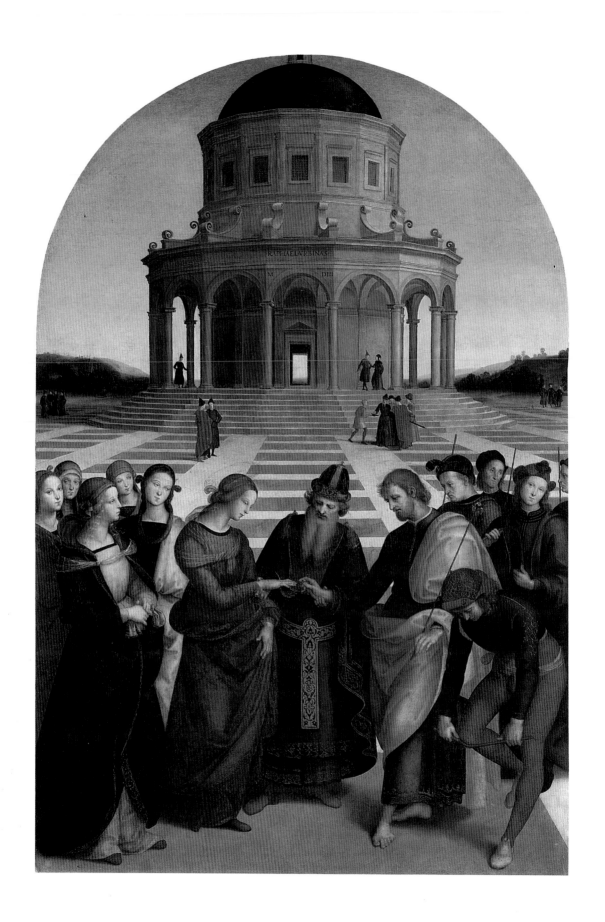

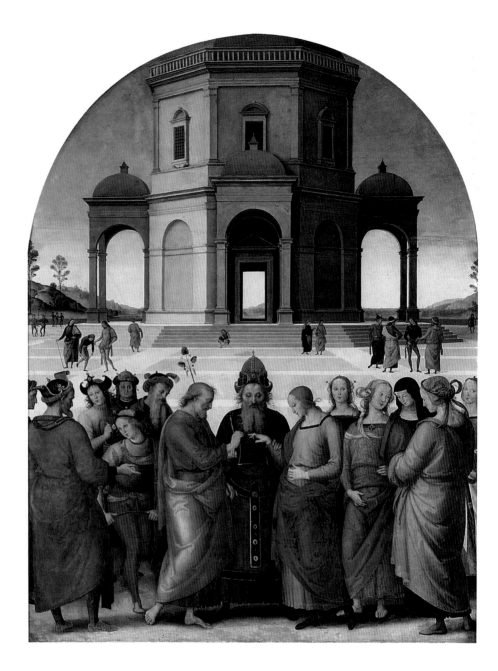

13 (right) Pietro Perugino
Marriage of the Virgin, ca. 1500–1504
Panel, 234 x 185 cm
Musée des Beaux-Arts, Caen

Perugino painted his *Marriage of the Virgin* for a chapel in the cathedral in Perugia, which was completed in 1489, and in which the Virgin's engagement ring was kept. This valuable relic had been stolen from a church in Chiusi in 1478 and had only recently been retrieved, so it is not surprising that it takes pride of place in the center of this picture.

12 (opposite) *Marriage of the Virgin (Sposalizio),* 1504
Panel, 170 x 118 cm
Pinacoteca di Brera, Milan

By painting his name and the date, 1504, in the frieze of the temple in the distance, Raphael abandoned anonymity and confidently announced himself as the creator of the work. The main figures stand in the foreground: Joseph is solemnly placing the ring on the Virgin's finger, and holding the flowering staff, the symbol that he is the chosen one, in his left hand. His wooden staff has blossomed, while those of the other suitors have remained dry. Two of the suitors, disappointed, are breaking their staffs.

arrange groups of people around the central figures in a semicircle, or on segments of part of a circle. This structure enabled him to clarify each figure's exact spatial position, while at the same time avoiding the impression of figures simply lined up in a row, which would quickly become monotonous.

The figures in the foreground of the *Marriage of the Virgin* (ill. 12) are grouped in this way. The success of the composition makes this painting, which is sometimes known by the Italian title of *Sposalizio,* a milestone in Raphael's early works. It was commissioned – probably with Perugino's *Marriage of the Virgin* (ill. 13) in mind

– for the Albizzini Chapel, dedicated to St. Joseph, in the church of San Francesco in Città di Castello. In Perugino's picture the figures are arranged in a broad immobile block in the foreground, and are lacking the fluid grace that their formal gestures, the graceful positioning of their feet, and their decorative and elaborate hats and head bands lead one to expect. Raphael's figures, by contrast, stand in contrapposto poses, with the soles of their feet firmly on the ground, and yet their well-formed bodies still display a graceful vitality. Raphael was also able, through the vividness of close observation, to depict the expectant tension of

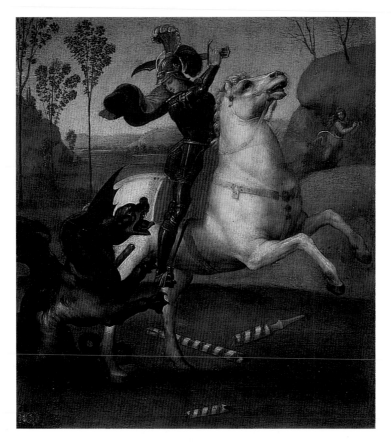

14 *St. George,* ca. 1504
Panel, 30.7 x 26.8 cm
Musée du Louvre, Paris

St. George's lance has been broken in the struggle, but the
proud knight is about to vanquish the dragon with the
sword, and so free the princess, who is fleeing on the
right. By the middle of the 16th century this panel
formed a pair with Raphael's *St. Michael* (ill. 15). Even
though the latter was painted somewhat earlier, the fact
that they are the same size and have a comparable
iconography implies that Raphael intended that the saints
should belong together.

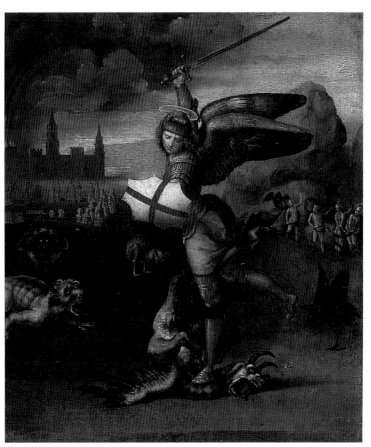

15 *St. Michael,* ca. 1503/04
Panel, 30.9 x 26.5 cm
Musée du Louvre, Paris

In a bleak landscape with the silhouette of a burning city
in the distance, Michael has just forced the Devil to the
ground and is about to kill him with a blow from his
sword. The monsters crawling out from all sides are
reminiscent of those created by Hieronymus Bosch, while
the figures in the center recall those from the Inferno of
Dante's epic poem the "Divine Comedy." On the left are
the hypocrites in leaden coats, condemned to follow their
torturous path, while on the right are the thieves being
tormented by serpents.

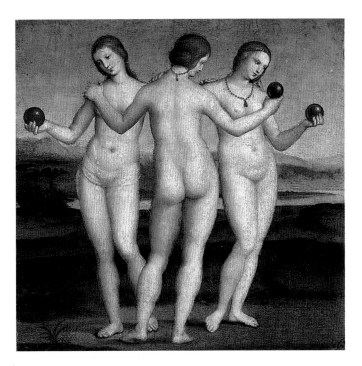

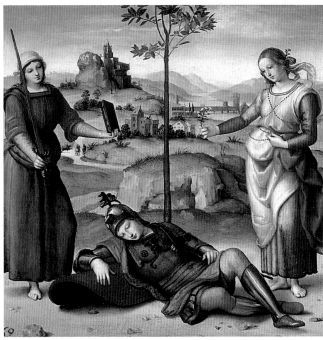

those present. The marriage is being completed by the giving of the ring, and Virgin's companions are shown reacting to the event: a woman in the second row is craning her neck so as to get a better view, and the woman in the left foreground – who starts the composition by leading the viewer towards the pictorial center – is gripping her own finger, on which there is no ring as yet, lost in thought.

Raphael's *Marriage of the Virgin* is also famous for its architecturally developed space, which is created by the use of a central perspective whose focus is the *tempietto* in the distance. Here, too, motifs from the work of Perugino served as models – taken not only from his *Marriage of the Virgin* but also from *The Giving of the Keys to St. Peter*, of 1481/82, a fresco in the Sistine Chapel. Raphael, however, increases the illusion that we are looking into a deep space by making the receding rectangular slabs of the floor-pattern become progressively smaller. He has also made a clear tonal distinction between them and a series of broad white stripes, which then emerge all the more clearly as lines converging on the central vanishing point. This gives the pictorial space a continuous rhythm that the viewer can follow without difficulty. In keeping with the laws of central perspective, the figures become smaller as they recede, and so define the distance between the foreground and the building in the background. The monumental size of this circular building is indicated by the size of the tiny figures in the colonnade surrounding it, the peristyle. In this painting Raphael succeeded in making the transitions between the different pictorial planes clear and continuous. The connection with the landscape, however, is still unclear.

The problem of integrating figures into landscape convincingly remained a much-debated issue until well into the 16th century. As figures were the key elements, since they conveyed the action, they were shown prominently in the foreground. The landscape played a subordinate role and often served as mere background, or even as something to fill an empty space. So Raphael's treatment of landscape in two small pictures probably painted shortly before his *Marriage of the Virgin* – one of St. George (ill. 14) and one of St. Michael (ill. 15) – is therefore all the more remarkable. These two panels were probably meant to be fitted together as a diptych, and, as they are small and light, they could be easily transported. In both the central figure comes thrusting forwards out of the depths of the pictorial space. The broad, apocalyptic landscape in which St. Michael battles against the Devil under a sky still glowing despite having darkened, sets the whole mood for the picture, and so can in no way be considered mere background.

Small pictures often have unusual subjects and often solve pictorial problems in surprising ways. One example is a panel, measuring only 17 x 17 cm, that depicts the naked three Graces in front of a landscape which looks like that of Umbria (ill. 16). Another is its companion piece: *Allegory (The Knight's Dream)* (ill. 17), which has the same dimensions, and whose precise subject matter is still debated. Like the panels depicting St. George and St. Michael, these two small paintings were presumably painted for the court of Urbino. This is suggested both by the exquisite execution and also by the subject matter of the *Allegory*. The painting probably depicts Scipio Africanus, whose story is recounted by the classical author Silius Italicus. Having fallen asleep

16 (above left) *The Three Graces*, ca. 1503/04
Panel, 17 x 17 cm
Musée Condé, Chantilly

This is Raphael's first study of the female nude in both front and back views. It was probably not based on living models, however, but on the classical sculpture group of the Three Graces in Siena. *The Three Graces* and the *Allegory (The Knight's Dream)* (ill. 17) probably belong together because they are identical in size. The disparity in the sizes of the figures, however, makes it difficult to believe that they were intended to form a diptych.

17 (above right) *Allegory (The Knight's Dream)*, ca. 1503/04
Panel, 17 x 17 cm
The National Gallery, London

A young knight is asleep in front of a laurel tree that divides the picture into two equal parts. There is a figure of a beautiful young woman in each half: on the left the personification of Virtue is holding a book and a sword above the sleeping figure, while the figure on the right is presenting a flower as a symbol of sensual pleasure. The probable meaning of the allegory is that the young man's task is to bring both sides of life into harmony.

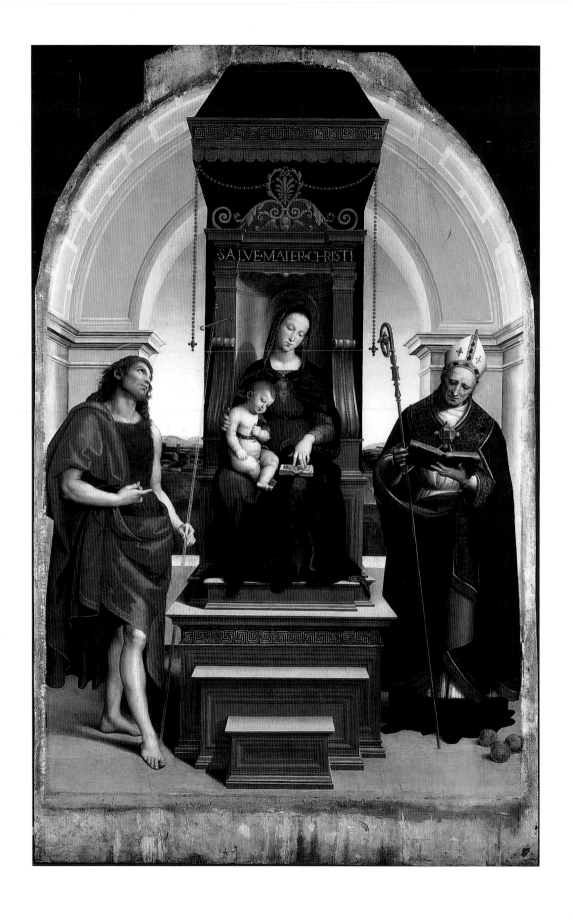

under a laurel tree, Scipio dreamt that two female figures, Virtue and Pleasure, challenged him to choose between them; Virtue pointed out the stony path which leads to her castle. Scipio, like Hercules before him, does not allow himself to be led astray, but follows Virtue. Raphael slightly modified the iconography, in that he gave both female figures symbols not mentioned in the text. Sword, book, and flower indicate qualities which a young courtly knight needed to distinguish himself as a soldier, as someone educated in the humanities, and as a tender lover. This description of the ideal courtier is given in the book "The Courtier" by Baldassare Castiglione, whom Raphael had met in Rome. Presumably, therefore, the *Allegory* presents us with a contemporary variant of the Scipio theme, exhorting us to merge and assimilate the various differing aspects of life. This view is supported by the landscape, which, as in the picture *St. Michael*, underscores the main theme. On the left-hand side, which is devoted to Virtue, an inaccessible fortress towers up on a steep hillside; whereas on the right a bridge stretches invitingly over a river. The two halves of the picture are not strictly divided from one another, however, for the hills behind the tree, as well as the cloudy sky, form part of a background that unites both sides. The contradictions suggested by the landscape motifs are thus resolved in the picture as a whole.

Early in his career Raphael was confronted by another theme very popular with Italian patrons: that of the *Sacra Conversazione*. This picture type shows the Madonna enthroned centrally, with saints on both sides, all the figures being contained within a single, unified space. Saints from many different periods could be grouped in various iconographic combinations. The donors' patron saints could be combined with local saints or those with an importance that reached beyond just one region, and the throne could be set in a room or in front of a landscape. An example of this picture type is the *Ansidei Madonna* (ill. 18). According to Vasari, Raphael painted it for Bernardino Ansidei's Chapel in the Servite Church of San Fiorenzo in Perugia, which was dedicated to St. Nicholas of Bari. This picture illustrates a problem which applies to the *Colonna Altarpiece* in New York, Raphael's first *Sacra Conversazione*, and which art historians are also discussing in relation to the *Coronation of the Virgin* (ill. 8). These two works appear to have been painted in two stages with intervals in between – which makes the exact date of completion uncertain. A date in Roman numerals appears on the hem of the Virgin's mantel in the *Ansidei Madonna*, but it is not certain what that date is. MDV, in other words 1505, is clearly visible; but then the V is followed by one or two further strokes, which could form part of the date, so that 1506 or 1507 are also possible dates of completion. However, the style of the painting suggests the first date is the most likely. At all events, the painting was started earlier, for the Virgin

and Christ Child still show Perugino's influence. Moreover, the perspective foreshortening of the throne, which is not deep enough for the Madonna, is unsuccessful. We can therefore assume that the artist began work on this painting even before he painted his *Marriage of the Virgin*. Nevertheless, the figure of Nicholas of Bari dominates the space and is so "present" as a rounded, three-dimensional body that we can assume that Raphael was beginning to respond to new influences when painting the *Ansidei Madonna*.

These influences were largely the result of the time Raphael spent in Florence from late 1504 or early 1505. This was probably not the first time that Raphael had visited the cradle and citadel of the Early Renaissance, but this stay marked an important stage in his development. He began enthusiastically to explore works by Leonardo and the young Michelangelo, whereas previously Perugino, Pinturicchio, Luca Signorelli, and Flemish artists such as Hans Memling had been important to him. This response to the works of other artists reveals a significant aspect of his own creative development: that he learnt as much from studying the art of others as he did from directly observing nature. What is important, however, is that he always endeavored not merely to imitate these models, but to surpass them.

By the time Raphael began his career, art from north of the Alps had for many years enjoyed a high reputation in Italy. One reason for this was the enamel-like brilliance of Flemish paintings, which were captivating both for their exact rendering of material appearances and for their realistic details. Painting with thin glazes of oil paint, Flemish artists had achieved a degree of luminosity in their works that Italian paintings of the period lacked. Not only Italian patrons, but also Italian artists developed a keen interest in Northern art. In his rhymed chronicle of the life of Federico da Montefeltre, Duke of Urbino, Raphael's father, Giovanni Santi, sang the praises of Rogier van der Weyden and Jan van Eyck. In fact Urbino played a particularly important role in introducing Northern art in Italy. In the 1470s in Urbino, Justus of Ghent, among others, worked on decorating the duke's study. Stylistically, Justus had much in common with the Ghent artist Hugo van der Goes, whose monumental *Portinari Altarpiece*, now in the Uffizi, was especially impressive because van der Goes had abandoned a charming beauty of line in favor of a more austere language of forms. His style had an enormous influence on Giovanni Santi himself – though not on his son.

Raphael was more interested in the art of Hans Memling. Memling, who worked in Bruges, the city of banking and trade, had important patrons in the city's wealthy Italian colony. Indeed, the sitter in his *Portrait of a Man with a Coin* (ill. 20) seems to be an Italian. It is not important whether Raphael knew this specific picture; what matters is that his own early *Portrait of a Man with an Apple* (ill. 21) owes a great deal to the portrait tradition that Memling

represented. Memling was one of the earliest artists to portray a sitter – usually shown in three-quarter profile – in front of a landscape, and thus to bring the open spaces of the outside world into the portrait. The exactly reproduced fur collar in Raphael's painting also indicates the influence of artists from north of the Alps. In the final analysis, however, it was the overall impression created by Memling's works, calm and harmonious, that appealed to Raphael, who was steeped in his own idealizing tradition of Italian art. Other paintings by Raphael also show a familiarity with Memling's works – the landscape in his *St. George and the Dragon* (ill. 25) in Washington, for example, owes a great deal to Memling's *St. John the Baptist* in the Alte Pinakothek in Munich.

German prints were also important to the young Raphael, who is known to have taken motifs from the engravings of Schongauer and Dürer. An example is his *Madonna and Child* in Pasadena (ill. 22), in which the delightful hilly landscape makes a convincing backdrop for the delicate figure of the Madonna. The small castle on the left is particularly attractive as it is reflected in the water. We can see clearly from the preparatory drawing in Oxford (ill. 23) that Raphael had neither invented this feature nor observed it direct from nature: he had in fact taken and adapted it, complete with the surrounding hills, from Dürer's engraving, *The Penance of St. John Chrysostom* (ill. 24). The reflection in the water, on the other hand, indicates the influence of Flemish painting. What is clear, then, is that Raphael did not simply copy such interesting models: he responded to Northern art creatively.

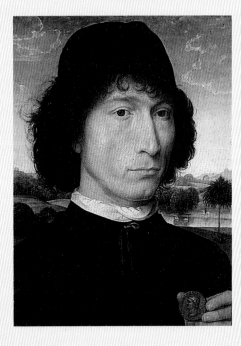

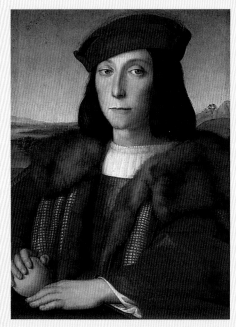

20 (far left) Hans Memling
Portrait of a Man with a Coin, ca. 1480–1490
Panel, 31 x 23.2 cm
Koninklijk Museum voor Schone Kunsten, Antwerp

In this portrait by the Flemish artist Hans Memling the sitter, shown holding a coin on which there is the head of the Roman Emperor Nero, is most likely Italian. The palm tree on the right, a reference to the south in an otherwise northern looking landscape, is an indication of this.

21 (left) *Portrait of a Man with an Apple*, ca. 1504
Panel, 47 x 35 cm
Galleria degli Uffizi, Florence

Despite many attempts, the identity of the man in the remarkable red clothes has not yet been discovered. It is probably Francesco Maria della Rovere, born in 1490, whose childless uncle Guidobaldo, the Duke of Urbino, had named him his heir. As the magnificent sable trimming of his clothes shows, the young sitter was undoubtedly of noble birth.

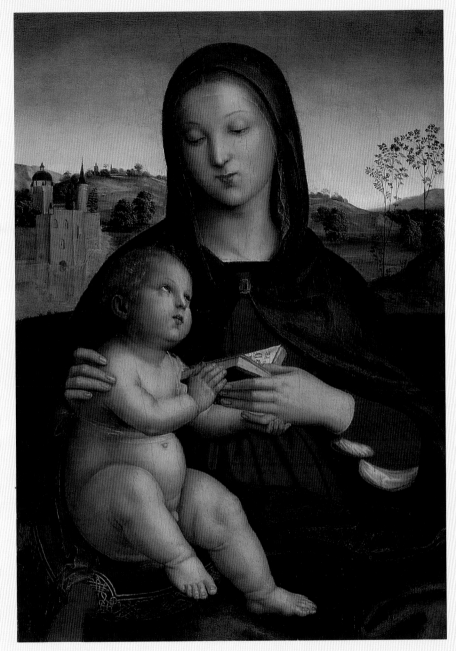

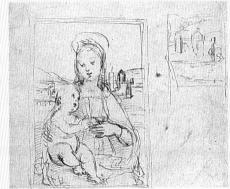

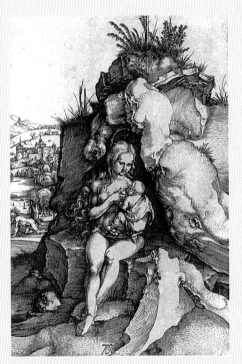

22 (above) *Madonna and Child*, ca. 1503
Panel, 39 x 28 cm
Norton Simon Museum of Art, Pasadena

The Madonna is holding the Christ Child with great tenderness. The two are also linked as they read the book of hours that is open at the prayer of Nones, the ninth hour after dawn in the Church's day. The hour of the Annunciation, when the Virgin conceived her son, the ninth hour was also the hour of His death on the Cross. Pausing from their reading, they look at each other thoughtfully, calmly meditating on the events to come.

23 (top right) *Madonna and Child*, ca. 1503
Pen and ink, 11.4 x 13 cm
Ashmolean Museum of Art and Archaeology, P II 508a, Oxford

This sketch is a study for the Pasadena *Madonna and Child* (ill. 22). The pose and the expression of the figures are the same as those in the painting, but Raphael had not yet decided on the landscape. The architecture in the background is on the left in the painting, but in the sketch is on the right. This part of the landscape appears again, larger and in more detail, on the right side of the drawing.

24 (bottom right) Albrecht Dürer
The Penance of St. John Chrysostom, ca. 1496
Engraving, 18.1 x 11.8 cm
Staatliche Kunstsammlungen, Kupferstichkabinett, Dresden

Raphael must certainly have known this engraving since he borrowed the landscape and the castle, which appear the same in the Oxford drawing (ill. 23) for the Pasadena *Madonna and Child* (ill. 22). Dürer's figures, however, were of no interest to Raphael.

THE CHALLENGE OF FLORENCE

25 *St. George and the Dragon,* ca. 1505/06
Panel, 28.5 x 21.5 cm
National Gallery of Art, Washington

St. George's struggle with the dragon is now over and the drama ended: the dragon has just been struck a fatal blow with the young knight's lance. The firm pyramidal composition, of which the white horse is a major part, also has a calming effect. The look of indifference on St. George's face is a result of the eyes having been painted over: originally he was looking straight at the monster.

26 (following double page, left) *Portrait of Agnolo Doni,* ca. 1506
65 x 45.7 cm
Palazzo Pitti, Galleria Palatina, Florence

In 1504 Agnolo Doni, a rich cloth merchant, married Maddalena Strozzi (ill. 27). These two portraits, which Vasari mentions, were originally in a hinged frame so that they could be opened and closed like a book. In a portrait diptych like this, a form very popular in the Renaissance, the man's portrait was usually on the left, the more important side heraldically.

27 (following double page, right) *Portrait of Maddalena Doni,* ca. 1506
Panel, 65 x 45.8 cm
Palazzo Pitti, Galleria Palatina, Florence

This portrait is more noticeably covered with a marked craquelure than its counterpart (ill. 26). These hairline cracks in the paint, which appear as the paint ages, particularly affect Maddalena's even features and full décolleté.

Raphael must have decided to go to Florence because he was convinced he could learn from other masters. He must also have heard of the artistic rivalry between Leonardo and Michelangelo, who were in the process of designing large-scale battle scenes for the Palazzo Vecchio (Town Hall) – according to Vasari this was the real reason why Raphael moved to Florence. Without doubt, however, he was attracted by the city itself, for it offered a wide range of the very best in new painting. Florence at this time, rather like the great museums of today, acted as a major art center, where students had the opportunity to train hand and eye by copying important paintings, deepening their understanding of composition. This is exactly what Raphael did when, according to Vasari, he studied not only Leonardo and Michelangelo, but also Masaccio. In Florence Raphael became part of a stimulating artistic milieu, and made friends with artists such as Aristotile da Sangallo, Ridolfo Ghirlandaio, and Fra Bartolommeo. Presumably it was also important to him to have the opportunity of gaining new, wealthy patrons.

It is not clear how long he planned to spend in Florence. According to Vasari, he soon interrupted his stay there in order to deal with his neglected affairs in Urbino, though there is no documentary record of when that actually happened. It is possible that it was during this visit to Urbino that he was commissioned to paint his *St. George and the Dragon* (ill. 25), which was completed 1505/06. The English Order of the Garter – a high distinction with which Henry VII of England had honored Guidobaldo da Montefeltre in 1504 – adorns the saint's left knee: the small panel may well have been meant as a gift for the King of England. A later visit to Urbino, for several months in 1507, is documented.

Raphael also seems to have returned to Perugia quite soon – immediately after his first visit to Urbino, according to Vasari – and it was probably at this time that he completed the *Ansidei Madonna* (ill. 18) and the *Colonna Altarpiece.* Raphael owed the Borghese *Entombment* (ill. 39) of 1507, the most famous commission of his time in Florence, to the Baglioni, the same Perugia family who had driven the Oddi into exile. Both families had a chapel in the church of San Francesco al Prato in Perugia. The *Coronation of the Virgin* (ill. 8) adorned the Oddi Chapel, and the *Entombment* the Baglioni Chapel. These two clans, which had been warring for decades, and whom Julius II tried to reconcile by means of a joint Mass said in San Francesco on 20 September 1506, probably continued their rivalry on the cultural front.

The clearest indication that Raphael had not permanently settled in Florence comes from a contract which he concluded on 12 December 1505 with the Poor Clares of Monteluce for a *Coronation of the Virgin.* It states that in the event of any legal disputes he could be found in Perugia, Assisi, Gubbio, Rome, Siena, Florence, Urbino, Venice, and "any other place" – an impressive list.

Perhaps Raphael planned to create an organization of workshops, in the style of Perugino's, which would make it possible for him to work in several different locations. But it is not clear whether he actually built up a studio in Florence with this in mind; whether, in other words, he was working with assistants. At all events, the painter Berto di Giovanni, who came from Perugia, is documented as a collaborator in the contract with the Poor Clares for the Monteluce *Coronation of the Virgin,* a work not in fact completed until after Raphael's death.

It is clear, however, that Raphael did not go to Florence as an unknown. On 1 October 1504, no less a person than Giovanna Feltria della Rovere, the sister of Guidobaldo da Montefeltre, had written a letter of recommendation to Pier Soderini, the *gonfaloniere della giustizia* of Florence, explicitly saying that the young artist wanted to "spend some time in Florence in order to learn," and asking for him to be given every assistance. In other words, Raphael was very well equipped for new challenges and must have entertained high hopes of gaining important patrons in Florence.

He obviously succeeded in this very promptly, for before his move to Rome in 1508 he had completed a number of altarpieces and devotional pictures. Vasari tells us who commissioned them. For a lawyer, Taddeo Taddei, Raphael painted the *Madonna of the Meadow* (ill. 31); for a friend, the draper Lorenzo Nasi, he painted the *Madonna with the Goldfinch* (ill. 34); for Domenico Canigiani, who was also a member of the Drapers' Guild, the *Canigiani Holy Family* (ill. 38); and, finally,

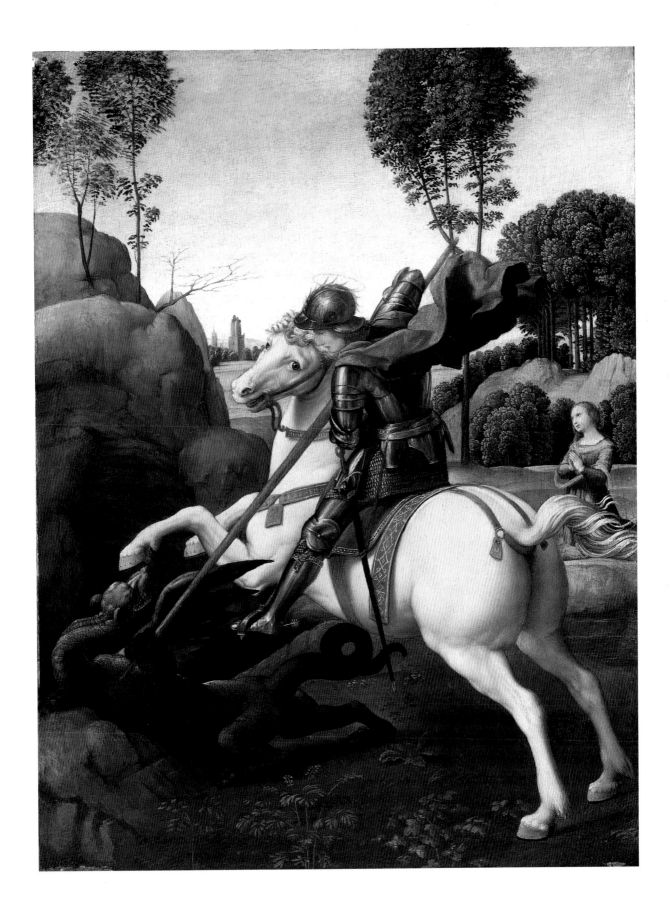

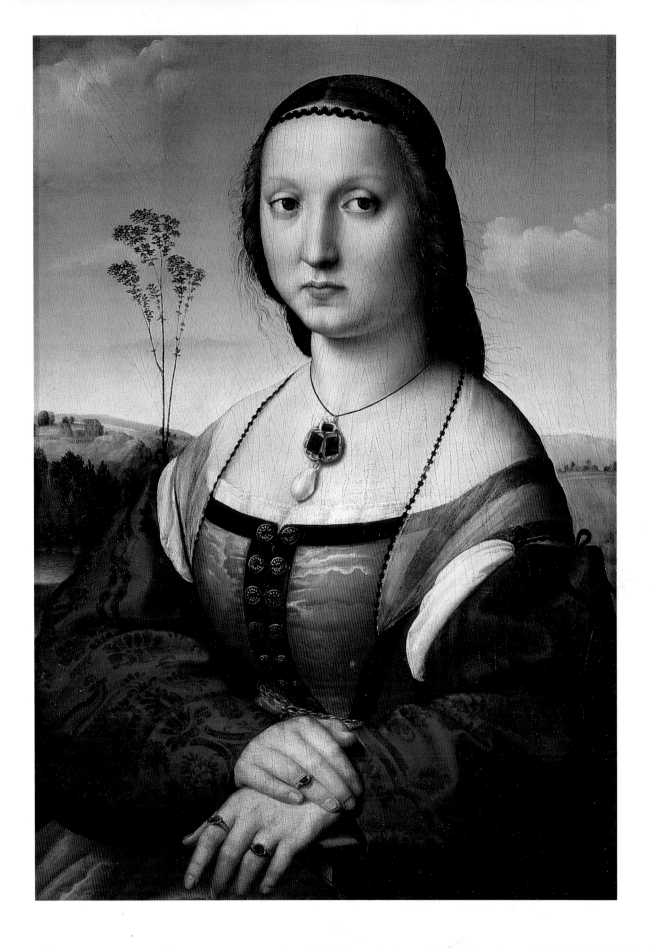

counterpoint to the heads, which are held self-confidently erect. The hands are clearly displayed, the subjects showing unmistakable pride in their precious rings. The two figures exude an air of calm confidence. The fact that both subjects are turning towards one another, and the continuing horizontal line formed by a cloud, half of which is in the left-hand picture and the other half in the right-hand one, make it clear that the portraits belong together as a pair. For a moment this apparent harmony conceals the fact that the sections of balustrade are not linked and so do not make sense architecturally, jutting into the picture as they do. This small inconsistency, however, is compensated by the boldness of the composition as a whole, and also by some of the wonderful details, such as the buttons and buckles, Maddalena's transparent shawl, beneath which shines her flawless skin, and Agnolo's white shirt, with its fine frill. These details are not painted pedantically: like everything else, they are blended together in a magnificent richness of color. Maddalena's salmon-pink dress, whose material, like watered silk, is shot through with a cloudy white, prefigures that freedom of brushwork found in Raphael's late Roman portraits.

Raphael's feeling for psychological nuance is shown in the subtle differences between the man and the woman. Agnolo Doni's head is turned more firmly into a three-quarter profile, so that the averted half of his face is in shadow, giving a sharpness to his features. On the other hand, the full, harmonious face of his wife, which is turned almost *en face*, is evenly lit, making it seem all the softer. In addition, the man is looking straight at the viewer, insisting on a direct encounter, whereas Maddalena's eyes are gently turned to the right, her whole figure appearing more restrained by comparison with her husband's. The delicately shaped tree on the left adds a gentle air to her portrait. By contrast, Doni's head stands out strikingly against the sky. The level clouds frame his head and so strengthen the pictorial structure – as does Doni's arm, which, lying parallel to the picture, acts as a kind of pedestal for the figure and holds the viewer at a respectful distance. Maddalena, on the other hand, turns to us in a much more open manner.

Raphael also valued a monochrome background, as in his *Portrait of a Pregnant Woman* (ill. 28), which he painted at about the same time as the Doni double portrait. Here, nothing distracts attention from the figure, which, by the very nature of the subject, has a strong physical presence, emphasized by the sitters gaze and her gesture.

The *Madonna del Granduca* (ill. 30), one of Raphael's earliest half-length Madonnas from his period in Florence, also stands against a dark background, and is therefore not within a specific space. In this portrait Raphael had now moved away from Perugino's figure type, which was still evident in his *Madonna Connestabile* (ill. 29), painted only a year earlier. The Madonna's face has become fuller, and the muscular Christ Child weighs heavily on her arm. As in the portraits, the bodies are now more three-dimensional, with the shadows, no longer confined to the figures'

28 *Portrait of a Pregnant Woman,* ca. 1506
Panel, 66.8 x 52.7 cm
Palazzo Pitti, Galleria Palatina, Florence

There are very few examples of portraits of a pregnant woman in Renaissance painting. Raphael shows great sensitivity for the special situation of the mother-to-be by showing both her fragility and her calm pride. Her left hand, resting protectively, gently emphasizes the swell of her stomach, while her gaze rests directly on the onlooker.

for the Dei family, who were also active in the silk and wool trade, the *Madonna with the Baldacchino* (ill. 50).

Raphael was able to prove his skill as a portrait painter when, probably in 1506, he painted Agnolo Doni and his wife, Maddalena (ills. 26, 27). As with *Portrait of a Man with an Apple* (ill. 21), Raphael chose a landscape as the background. In the earlier portrait, however, there is still some uncertainty as to the man's exact spatial relationship with the balustrade (or table) on which his hands are resting. In the Doni double portrait, by contrast, the broader view of the two figures makes it completely clear that the figures are sitting, with their arms resting on a balustrade. The well-manicured hands do not need to be artificially occupied, by holding something. They are now put to better use as a

29 (below) *Madonna Connestabile,* ca. 1503/04
Panel transferred to canvas, 17.5 cm in diameter
Hermitage, St. Petersburg

Raphael met the challenge of creating a round
composition when he painted this delicate Madonna. He
provides a stable structure for the round picture by means
of the vertical figure of the Madonna and the horizontal
lines of the landscape. The Madonna's head is gently
inclined and the contour of her left hand flows
rhythmically into the outline of the Christ Child's body,
thus responding to the circular form.

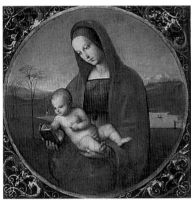

30 (right) Madonna *del Granduca,* ca. 1505
Panel, 84 x 55 cm
Palazzo Pitti, Galleria Palatina, Florence

The Virgin is holding her son with a look of great
solemnity. Both are looking at the observer, which creates
the impression that the observer too is redeemed by
Christ's death. Raphael had originally planned an
architectural background, which he later painted over.
The resulting dark ground creates a sense of meaningful
stillness and ensures that the observer's attention rests on
the figures.

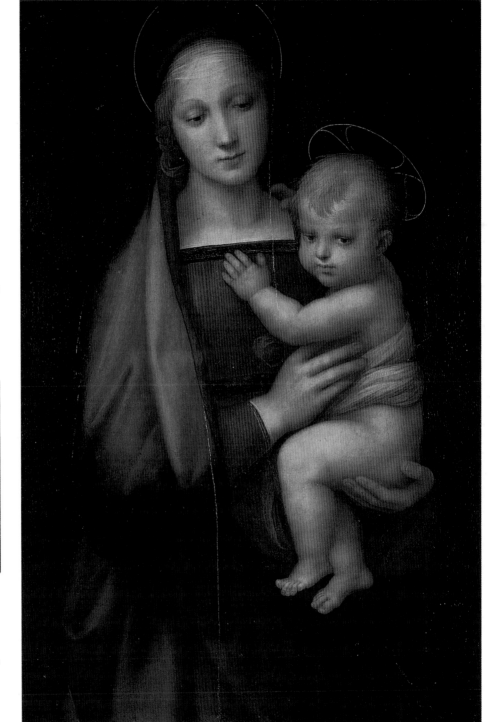

outlines, enveloping the figures. Accessories are now no longer needed to occupy the Virgin or the Christ Child. These changes result in the figures gaining inner dignity, which makes their solemnity all the more credible.

In the case of the *Madonna del Granduca*, art historians have rightly emphasized the important influence of Fra Bartolommeo, whose heavy figures are enveloped by voluminous garments. Raphael was striving to achieve monumentality, and he obviously found this in the works of the Dominican monk, who had become a friend.

However, the most important influences on Raphael's creative development during his stay in Florence were Leonardo and Michelangelo, who now took the place of Perugino. His *Portrait of Maddalena Doni* (ill. 27) seems to be related to Leonardo's *Mona Lisa*, and Raphael's full-length landscape Madonnas would be inconceivable without the example of Leonardo's innovations. In Raphael's *Madonna of the Meadow* (ill. 31), *Madonna with the Goldfinch* (ill. 34), and *La Belle Jardinière* (ill. 36), the mother-child group has been extended to include the boy Baptist. In *The Holy Family with a Lamb* (ill. 37), Joseph also appears, and the *Canigiani Holy Family* (ill. 38) includes Elizabeth, the mother of St. John the Baptist. As with the *Madonna Ansidei* (ill. 18), here, too, it is difficult to decipher the dates in

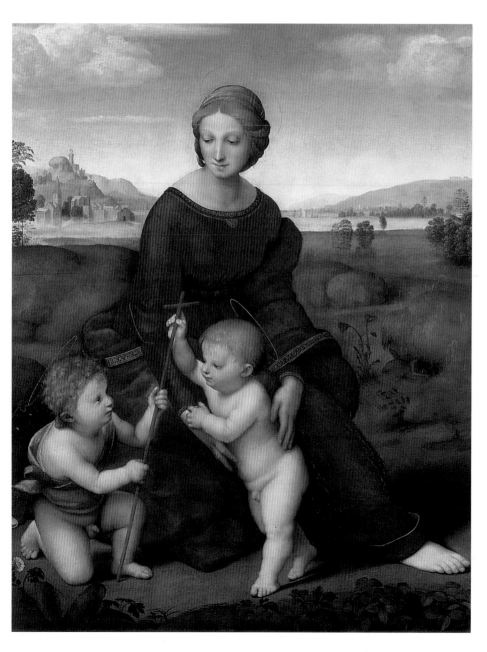

31 (left) *Madonna of the Meadow,* 1505 or 1506
Panel, 113 x 88 cm
Kunsthistorisches Museum, Vienna

The *Madonna of the Meadow* is the first of a series of full-length figure compositions that portray the apocryphal encounter between the Child Jesus and the boy Baptist. The boy Baptist is supposed to have recognized and worshipped Christ as the Redeemer even in their childhood. Raphael makes this clear by letting Christ take the cross from John.

32 (opposite) Leonardo da Vinci
Madonna of the Rocks, ca. 1483
Panel transferred to canvas, 199 x 122 cm
Musée du Louvre, Paris

The figures have been transposed into what looks like a dark, mysteriously illuminated cavern. The Virgin, young and tender, is holding the boy Baptist, who is looking at Christ in adoration. This is puzzling, for her son, raising His hand in blessing, is sitting dangerously close to the edge of an abyss. But an angel protects the Christ Child with a light touch of the hand, which the Virgin's dramatically outstretched left hand cannot do.

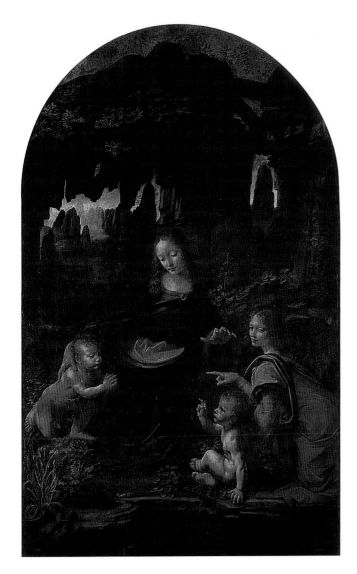

the picture. It is not clear whether the *Madonna of the Meadow* is dated 1505 or 1506, and whether 1507 or 1508 is the correct date for *La Belle Jardinière*. The chronology of these pictures is important, however, for they show Raphael's growing confidence in adapting Leonardo's formulas in his own individual way in both the form and the content of his works. During the same period, Raphael was also responding to Michelangelo's early sculptures, the second great challenge to which Raphael responded with ever more convincing solutions.

As early as the Vienna *Madonna of the Meadow* (ill. 31), Raphael had employed the basic compositional structure of a pyramid: he recognized in it the magic ingredient in Leonardo's works, for it was a means of arranging figures spatially in a compact group. He saw examples of it in Leonardo's *Madonna of the Rocks* (ill. 32), and also his *Virgin and Child with St. Anne* (ill. 33). In these works the figures are connected by looks and gestures in so complex a way that in this early attempt Raphael could not live up to the original in composition. The Virgin's foot in particular, which marks the lower right-hand corner of the triangle, extends rather too conspicuously from under her robe. The upper body seems flat, though her head is powerfully accentuated and her shoulders are shown to advantage as the blue mantle no longer covers her head. The boy Baptist is a direct quotation from Leonardo's *Madonna of the Rocks* (ill. 32), and the Virgin's long right arm is taken from the *Virgin and Child with St. Anne* (ill. 33). However, these motifs are not fully integrated. The way the Virgin Mary is holding her arms separates Jesus from St. John, so that the playful handing over of the cross, despite its great importance, seems a little forced.

33 (above) Leonardo da Vinci
Virgin and Child with St. Anne, ca. 1508–1510
Panel, 169 x 130 cm
Musée du Louvre, Paris

The Virgin is sitting before a "world landscape", as it is known, on the lap of her mother Anne, reaching out to the Child who is playfully pulling a lamb towards him by the ear, thereby indicating the coming events of the Passion (Christ is the Lamb of God). Raphael uses a similar pyramidal composition in several of his works. The lamb reappears in *The Holy Family with a Lamb* (ill. 37).

35 (above) Michelangelo
Madonna and Child, ca. 1503–1506
Marble, height 128 cm
Cathedral of Our Lady, Bruges

The young Michelangelo was working on this marble statue while Raphael was in Florence. Raphael was impressed by the three-dimensionality of the monumental bodies, as well as by the profound solemnity of the Mother and Child. The statue was bought by the Mouscron family, wealthy Flemish merchants.

34 (left) *Madonna with the Goldfinch,* ca. 1506
Panel, 107 x 77 cm
Galleria degli Uffizi, Florence

The Christ Child is lovingly stroking a goldfinch that the boy Baptist has just given him. A symbol of the Passion (the goldfinch, because it feeds among thorns) is thus combined in a scene that can at a first level of meaning be seen simply as children at play. This picture, which Raphael painted for the marriage of his friend Lorenzo Nasi and Sandra di Matteo di Giovanni Canigiani, was badly damaged when Nasi's house collapsed in 1548.

In his *Madonna with the Goldfinch* (ill. 34), Raphael was far more successful both in integrating the symbols of the Passion into a natural-looking scene, and also in relating the figures through their gestures. As in Leonardo's *Madonna of the Rocks* and in Raphael's own *Madonna of the Meadow*, the Virgin has turned her head towards the boy Baptist; but here she also has her arm around him and is moving him closer to Christ, who is standing safe and secure between his mother's legs. Compared to the *Madonna of the Meadow*, the whole group is conceived more three-dimensionally, and, largely because of the rock on which the Virgin is sitting, is more fully integrated into the landscape. Here the borrowed figure motifs owe more to Michelangelo than

36 *La Belle Jardinière,* 1507 or 1508
Panel, 122 x 80 cm
Musée du Louvre, Paris

This painting is the highpoint of all Raphael's Florentine
Madonnas. The bodies occupy the space with great
freedom, while the figures interact with deep feeling. The
arch formed by the frame completes the composition
harmoniously. Raphael put the date of the picture into
the hem of the Virgin's mantle, as he often did, but it is
not clear if the Roman numerals are meant to be read as
1507 or 1508.

to Leonardo. Michelangelo's Bruges *Madonna and
Child* (ill. 35) clearly anticipates the narrow but fully
three-dimensional group of the painting. Moreover, in
Michelangelo's sculpture, as in the *Madonna of the Rocks*,
the Christ Child stands safe and secure between the legs
of the Virgin, whose upper body is straight and firm,
and whose knees thrust forward powerfully. Here, as

he did when under Perugino's influence, Raphael has
combined figures from various sources – the Christ
Child recalls Michelangelo's *Pitti Tondo*, now in the
Bargello, Florence.

The various motifs in Raphael's *La Belle Jardinière*
(ill. 36) blend together with remarkable success. Here,
a staff and a book function as the symbols of the Passion,

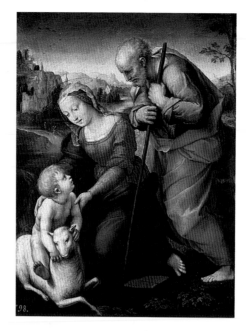

37 *The Holy Family with a Lamb,* 1507 (?)
Panel, 29 x 21 cm
Museo Nacional del Prado, Madrid

There are several versions of this picture, which all show the Virgin holding Christ riding on a lamb while the elderly Joseph presides over the family. This version, in Madrid, was later marked with the words RAPHAEL URBINAS MDVII on the Virgin's décolleté. As Pedretti has pointed out, the version in Vaduz is dated 1504, and signed, so that it may be considered the original.

38 (opposite) *Canigiani Holy Family,* ca. 1507
Panel, 131 x 107 cm
Bayerische Staatsgemäldesammlungen, Alte Pinakothek, Munich

This is an example of Raphael's favorite form of group composition during his Florentine period, the monumental pyramid. The Virgin and Elizabeth are sitting on the grass with their children, and Joseph is standing over them – this shows the importance of Jesus' adoptive father, and gives expression to the increase in the worship of Joseph after 1500. In 1982 the German conservator Hubert von Sonnenburg undertook a careful restoration of this picture and removed a distorting blue overpaint, dating from the 18th century, from the sky area. Raphael's original concept, with the putti on the upper left and right, can now be admired anew.

but they are of secondary interest. The figures gaze intently at each other, and touch, the result being a denser psychological texture. Here the boy Baptist is now no longer as fully integrated into the scene as he was in the *Madonna with the Goldfinch* (ill. 34). Instead, he is given a role he had already fulfilled in the *Colonna Altarpiece* and the *Ansidei Madonna* (ill. 18). That is, he is a figure with which the viewer, who is being urged to worship the Redeemer, can closely identify, safe in the knowledge of the Virgin Mary's loving intercession. In *La Belle Jardinière*, Raphael borrowed the Christ Child from Michelangelo's Bruges *Madonna and Child*. Raphael, however, shows the Child turning towards His mother, who is calmly sitting on a rock without having to turn her body, as she does in the *Madonna in the Meadow*. A voluminous mantle gives the figure great fullness, especially as the physical forms have become even more three-dimensional and majestic. Furthermore, showing the figure of the Virgin Mary in three-quarter profile allowed Raphael to integrate it more fully into the surrounding space. This integration is most fully realized, however, through the use of Leonardo's technique of *sfumato*, which allows a painter to model color tones through gentle gradations rather than harsh transitions. Raphael's study of Leonardo's aerial perspective also helped him to depict the broad landscape as a continuous whole – the mountains and the city lose their sharpness as they recede into the distance.

One special challenge for Raphael during this period must have been Atalanta Baglioni's commission for a scene from the *Passion of Christ* (ill. 39), which he painted in Perugia and which is now in the Galleria Borghese in Rome. In 1500, Atalanta's son, Grifonetto, was murdered by Gianpaolo Baglioni and his associates

– in other words, by a member of his own family. This was hardly surprising, for not long before Grifonetto had attempted to kill all the other Baglioni. Gianpaolo was able to escape, and he avenged himself on Grifonetto, who had in the meanwhile repented. Grifonetto died in his mother's arms after she had begged him to forgive his killers.

It is not clear when Raphael received this commission, though the painting is dated 1507, the year it was completed. A long process of design preceded the final work. Raphael frequently changed his mind, and even altered the pictorial theme. Initially, he planned to paint a Lamentation of Christ modelled on one by Perugino, dated 1495, for the church of Santa Chiara in Florence, a painting now in the Palazzo Pitti. A Raphael drawing in Oxford (ill. 43) is exactly like Perugino's painting, and shows a calm, undramatic composition intended for a thoughtful, sorrowing viewer. Christ's body lies in the foremost pictorial plane. His head and upper body are resting on the knees of His mother, who seems about to sink backwards into the arms of two women, who are supporting her. Christ's legs are lying on the lap of Mary Magdalene, who is gazing at Christ with her hands folded in prayer. St. John, mourning silently and immersed in his own thoughts, is standing among a group of other men on the right. The mood matches that of Perugino's picture, and it is conceivable that Atalanta Baglioni, who like Perugino came from Perugia, asked for a composition in the style of the older master. If that is the case, Raphael succeeded in convincing her to accept a different conception with more dramatic power.

In the picture he delivered (ill. 39), the heavy body of Christ is carried to the tomb by two strong men who clearly show the physical strain they are under. This means that action – not silent mourning – is in the forefront of the picture. Mary Magdalene has accompanied the dead Christ and is holding his lifeless hand. Boundless pain is reflected in her facial expression: her mouth is open in lamentation, and deep furrows are etched into her smooth forehead. The whole scene is conceived in dramatic terms – the tunic of the man carrying on the right is blowing to one side, as is Mary Magdalene's hair. The group on the right around the Virgin Mary is separated from the main scene, and she has collapsed, as if dead, into the arms of the women holding her. Here, instead of gracefulness, the artist has depicted an infinite suffering that is totally convincing in its naturalness.

A compositional problem Raphael faced here was how to show both groups as independent pictorial centers without allowing them to become two unrelated sections. He developed various solutions in several figure and group studies. In the course of this painting's development, the group around the Virgin moved to the right and became increasingly isolated. The result was that this group formed a kind of devotional picture within the main narrative, where the focus was on action. This creates a contrast between an active and a passive group, with the figures of the swooning Virgin and the dead Christ having a formal function as mirror

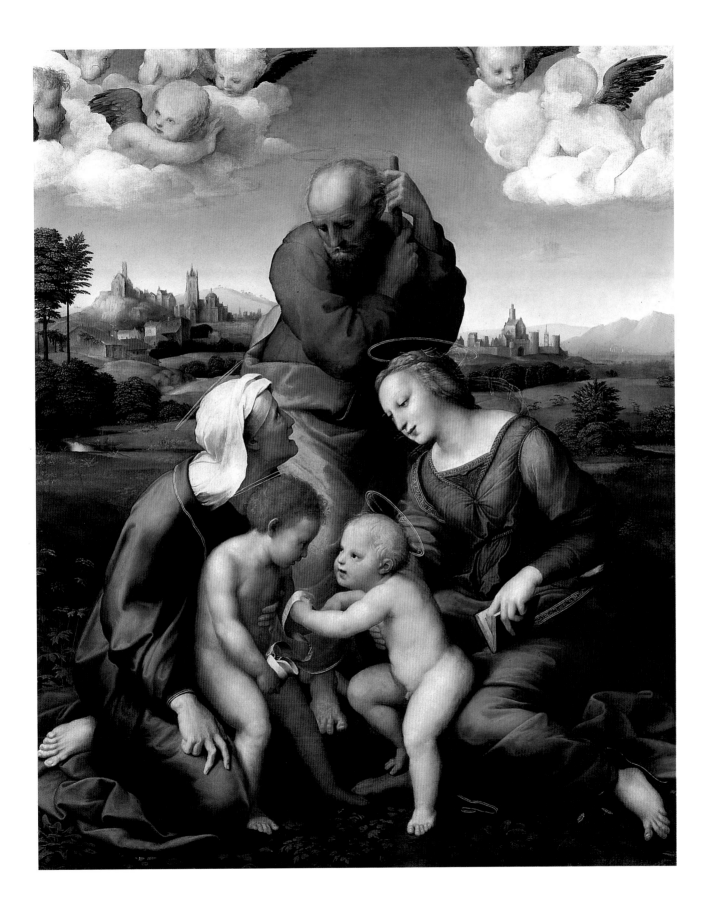

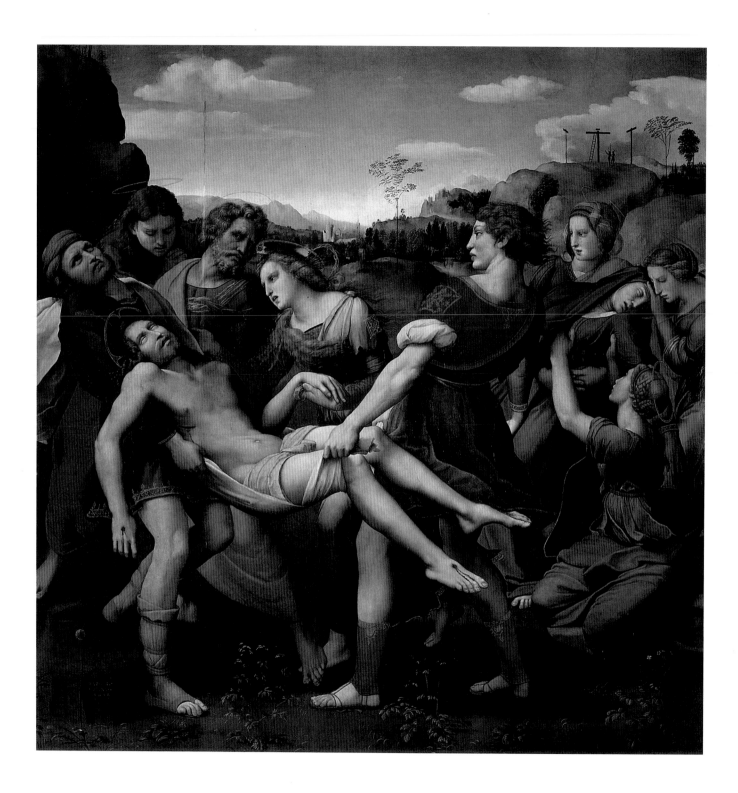

39 (opposite) *Entombment,* 1507
Panel, 184 x 176 cm
Museo Galleria Borghese, Rome

Atalanta Baglioni ordered this altarpiece for her family
chapel in the church of San Francesco al Prato in Perugia.
It remains pure speculation whether it was really meant to
commemorate her son Grifonetto, murdered in 1500, but
the subject of the picture would then be quite
understandable, since Atalanta may have identified with
the pain of the swooning Virgin as her son is carried to
his grave.

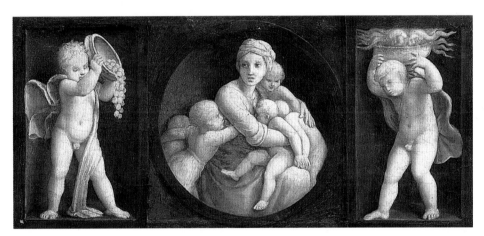

40 – 42 (right) *The Theological Virtues Faith, Hope,
and Charity* (predella of the *Entombment*), 1507
Panel, each 16 x 44 cm
Museo Galleria Borghese, Rome

Raphael executed the three Virtues of Faith, Hope, and
Charity, which form the predella of the *Entombment*, in
grisaille. At first glance they look like sculptures on the
flattish, only slightly concave ground. Raphael is not
simply imitating sculpture, however: he is also asserting
the superiority of painting over sculpture, his
contribution to the Renaissance contests between the arts,
the *paragone*. In painting he can show the smallest detail,
such as a single hair, while a sculptor's limits are set by his
materials. The garments, too, flow and move in a way in
which no sculptor could capture. The gray-on-gray
painted figures, then, are presented as being more life-like
than sculpture; painting proves to be the greater art in a
direct comparison with sculpture. Given that Raphael was
familiar with the sculptures of the young Michelangelo,
the *paragone,* which appears only in the predella, is given
a clear contemporary reference.

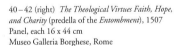

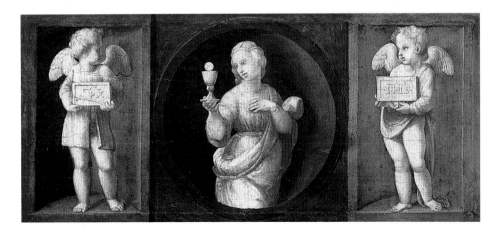

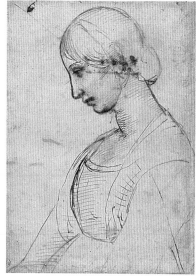

images of one another, the Virgin supported and Christ carried.

In the squared-up *modello* (ill. 45) we can still see, between Mary Magdalene and the man on the right carrying Christ, a woman who thematically belongs to the group around the Virgin. Raphael eventually moved her to the right: her gaze towards the dead Christ now establishes the link between the two groups.

By changing the subject of his picture from a Lamentation of Christ to an Entombment, Raphael created the only large-scale narrative composition of his Florentine period. It represents an aspect of his art he was later to develop superbly in his Vatican frescoes.

As in the painting of his great Madonna pictures, in the development of the Borghese *Entombment* Raphael learnt a great deal by studying a wide range of works by other artists. The division of the composition into two sections can be found in a famous engraving of the Entombment of Christ by Andrea Mantegna, in which both the man carrying on the left and the motif of the swooning Virgin can also be seen. Another source of inspiration, presumably, was a classical sarcophagus depicting the burial of Meleager, now in the Vatican. Michelangelo, too, played an important role once again. The muscular woman who turns to face the Virgin and supports her with outstretched arms (ill. 46) quotes the figure of the Virgin Mary in his *Doni Tondo* (ill. 47). In

this figure we can already detect the monumentality that would later characterize Raphael's four seated figures on the ceiling of the Stanza della Segnatura (ill. 51), and also the last works he painted in Florence, around 1508.

In the predella paintings of the *Entombment* (ills. 40–42), painted in grisaille, Raphael once again experimented with figures who turn about their own body's axis in a series of twists both forwards and backwards. They follow the principle of the *figura serpentinata* which he had learnt from Leonardo and Michelangelo. The Christ Child in the earlier painting, *La Belle Jardinière* (ill. 36), is turning his upper body to the left, whilst his legs face front and his hips are slightly turned towards the right. But in that picture it is more of a lively gesture than a complex turn. The figure of Faith in the predella (ill. 42), by contrast, is turning about her own body's axis, a movement which in his *St. Catherine* (ill. 48) has evolved into a remarkable spiral twist. The motif is effectively emphasized by the folds in St. Catherine's thin dress and delicate veil. The material of her mantle, which has become reversed over her hips, so that the yellow inner side shines out brightly, also forms part of this movement. By employing this form of twisting turn Raphael was able to make the figure vividly three-dimensional and to free himself of the two-dimensionality which was still evident in the *Madonna of the Meadow* (ill. 31).

43 (above left) *Lamentation over the Dead Christ*, ca. 1505
Pen and ink over stylus underdrawing, 17.6 x 20.6 cm
Ashmolean Museum of Art and Archaeology, P II 29, Oxford

This drawing, which is the first of Raphael's designs for the composition for Atalanta Baglioni's altarpiece, is little more than a sketch. The area of the picture is hastily defined, and the outlines of the figures, whose depth and shadow have been indicated by hatching, are loosely sketched. At this stage the subject is that of a Lamentation rather than an Entombment.

44 (above right) *Waist-length Figure of a Young Woman*, 1506
Pen and ink over stylus underdrawing, 26.2 x 18.9 cm
Galleria degli Uffizi, Gabinetto dei Disegni e delle Stampe, Inv. 1477E, Florence

The young woman, whose upper body is leaning slightly backwards with her head inclined forwards, is drawn in a sitting pose with just a few strategically placed strokes of the pen. She might have been the model for the Magdalene in the Uffizi drawing (ill. 45). If so, then Raphael changed only the position of the head when he put her into the complete composition.

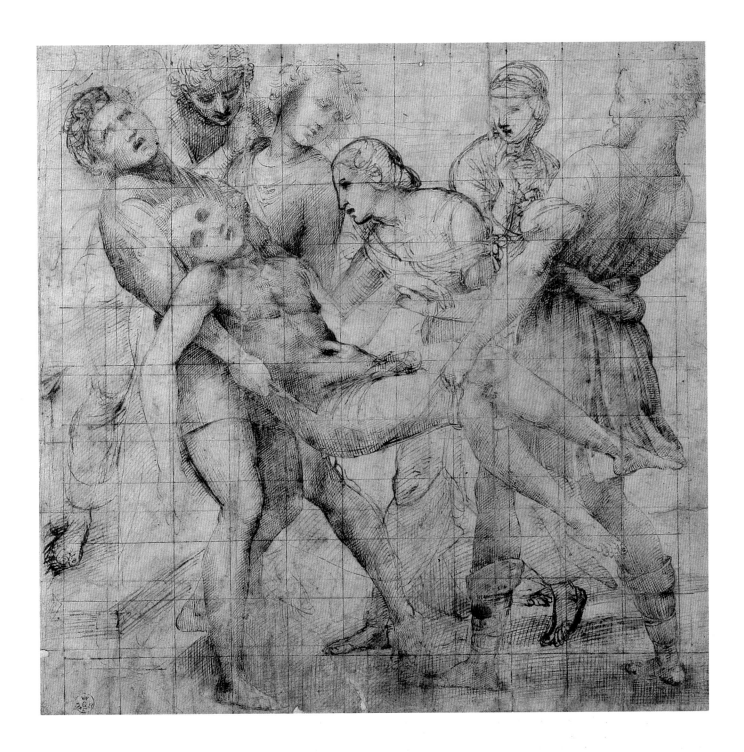

45 *Entombment*, 1507
Pen and ink over traces of lead point, in stylus, pen and
ink, and red chalk, squared, 28.9 x 29.7 cm
Galleria degli Uffizi, Gabinetto dei Disegni e delle Stampe,
Inv. 538E, Florence

This drawing has preserved the actual *modello* for the group on the
left in the *Entombment* (ill. 39). It is the last study, in which the
final composition is for the most part established. Squaring enabled
the drawing, which was on a smaller scale, to be transferred easily to
the larger format of the painting.

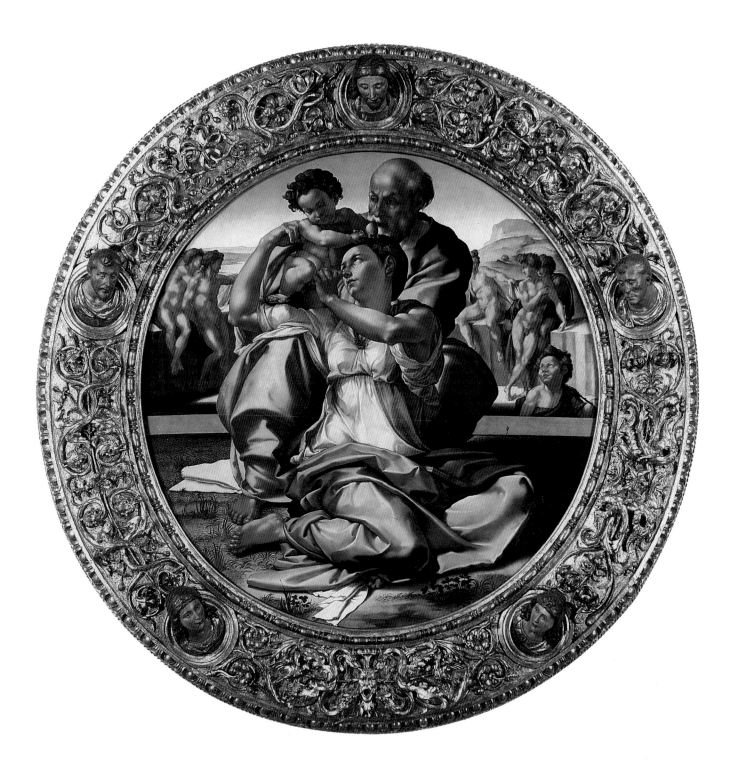

46 (opposite) *Entombment* (detail ill. 39), 1507

Not until a late stage in the development did Raphael move the group around the swooning Virgin to the right of the picture, thus creating a second focus of action. The figure of the kneeling woman, an ambitious figure Raphael had borrowed from Michelangelo's *Doni Tondo* (ill. 47), now comes into its own.

47 (above) Michelangelo
Doni Tondo, ca. 1504/1506 (?)
Panel, 120 cm in diameter
Galleria degli Uffizi, Florence

Unlike Raphael's paintings, the contents of Michelangelo's are often hard to understand. The Holy Family is in the foreground.

The Virgin, a muscular young woman, is turning round with a complicated movement to take the Christ Child Joseph is handing to her over her shoulder. The meaning of this scene is both theologically and philosophically obscure, as is the significance of naked young men in the background.

48 (below left) *St. Catherine*, ca. 1508
Panel, 71 x 56 cm
The National Gallery, London

St. Catherine of Alexandria is portrayed in a marvellous, twisted pose. Her left arm is leaning on her attribute, the wheel, and her right hand is pressed to her breast while she gazes up at a sky flooded with light. The composition is as rich in harmonious movement as the coloration is full and varied.

49 (below right) *Tempi Madonna*, ca. 1507/08
Panel, 75 x 51 cm
Bayerische Staatsgemäldesammlungen, Alte Pinakothek, Munich

The Virgin is holding the Christ Child closely and tenderly. She has eyes only for him, but the Child is looking at the observer, and so draws us into the intimate scene. The rapidly applied color on the veil, where the paint has been modelled by brush strokes while still wet, shows Raphael using his materials much more freely than in his earlier panel paintings.

Raphael's Madonnas of his late Florentine period appear to dominate their space, if only because a larger proportion of the figure is shown, including the hips. This effect is determined by the pose the Virgin Mary adopts, which is a three-quarter profile. An exquisite example is provided by the *Tempi Madonna* (ill. 49), a picture made especially captivating by the natural intimacy that exists between mother and child. The wide range of formal possibilities now available to Raphael for presenting a devotional image of the Virgin and Child without using traditional attributes is further illustrated by the *Large Cowper Madonna* of 1508, now in the National Gallery, Washington.

In a letter dated 21 April 1508 to his uncle, Simone Ciarla, in Urbino, Raphael mentions a painting for which, by Easter, he had already completed a cartoon. This is generally thought to be his *Madonna with the Baldacchino* (ill. 50). It was intended for the chapel of the Dei family in the church of Santo Spirito, in Florence, though it had still not been completed when Raphael moved to Rome. In his will of 20 July 1506, Rinieri di Bernardo Dei had expressed his wish to have the altarpiece painted, and gave detailed instructions

about what it should contain. Thus, St. Bernard, his patron saint, was to appear in the picture – he is standing behind St. Peter. The Dei family did not, in fact, accept the uncompleted altarpiece. They preferred to commission a replacement from Rosso, a Madonna that is dated 1522 and that, like the *Madonna with the Baldacchino*, is now hanging in the Palazzo Pitti. The unfinished work remained in Raphael's possession, and after his death his executor, Baldassare Turrini, purchased it for his own chapel in Pescia Cathedral.

In the light of this complicated history it is not surprising that for a long time it was unclear which parts Raphael had painted himself, and which might have been painted by another artist later. The most recent restoration work, however, has removed all doubts about the picture's authenticity. Apart from a horizontal strip along the top edge, which was added later, Raphael painted the whole picture himself. Even the angels, whose coloration and figurative vitality seem astonishingly modern, were also his work.

When compared with his earlier *Sacra Conversazione*, this painting is impressive by virtue of the freedom and authority of its use of space. The throne has been placed

50 *Madonna with the Baldacchino,* 1507/08
Panel, 276 x 224 cm
Palazzo Pitti, Galleria Palatina, Florence

When Raphael went from Florence to Rome in 1508, this picture remained behind unfinished. The Virgin is enthroned beneath a baldacchino. St. Peter and St. Bernard are on the left, while St. Augustine, and probably St. James the Elder, stand on the right. The restoration carried out in 1991 proved that all parts of the painting were by Raphael's hand, except the strip above the columns, which was added in 1697.

in a large semi-circular apse and leaves plenty of room for the saints, who turn to one another in lively conversation or point towards the Virgin Mary. Against the concave background of the imitation-classical architecture, the baldacchino projects forward in a convex shape, balancing the spatial relationships. The models cited for this superb composition include Venetian paintings, as well as works by Fra Bartolommeo, whose monumental figures in Florence fascinated Raphael.

It is difficult to confirm what exactly his models were, but by 1508 Raphael was certainly ready for a further step in his career, and entirely equal to the challenges he was to meet in Rome.

Raphael's Career in Rome: 1508–1513. The Pontificate of Julius II

51 Ceiling of the Stanza della Segnatura, ca. 1508–1511
Vaticano, Stanza della Segnatura, Rome

51 Ceiling of the Stanza della Segnatura, ca. 1508–1511
Vaticano, Stanza della Segnatura, Rome

The ceiling design is attributed to Sodoma, but he painted only the central octagon and the small spaces between the tondi. Raphael painted the personifications of Philosophy, Poetry, Theology, and Justice, as well as the four large panels in the corners, whose subjects refer to the two adjacent personifications. The architectural frames and their decorations are thought to be the work of a German painter, Jan Ruysch.

The remarkable career that awaited Raphael in Rome was meteoric. It was also to be brief. The credit for having recognized and fostered his talent is shared by two popes: Julius II, of the della Rovere family, and his immediate successor, Leo X, a Medici. Neither acted unselfishly in this: they both saw in Raphael a congenial collaborator in their struggle to create a humanistically colored vision of the papacy. The two popes differed in their character, taste, culture, and political program. Yet the *Restauratio Romae* gave them a common goal: to restore ancient Rome's cultural and political importance under papal leadership.

As early as 1453 Nicholas V had begun reconstructing and extending a 13th-century building in the Vatican. Later, the Borgia pope, Alexander VI, used some of the apartments on the first floor of the north wing, and it was here that his successor, Julius II, resided at the beginning of his pontificate. Towards the end of 1507 Julius decided to refurbish the second floor, the so-called Stanze, because he no longer wished to live in the apartments occupied by his predecessor, whom he detested. He was annoyed by the frescoes Pinturicchio had painted for Alexander – less for any artistic statement they made than because they displayed Alexander's insignia everywhere. The artists whom Julius II commissioned to paint frescoes in the new apartments included Perugino and Sodoma, an artist who lived in Siena. Raphael took over this work on his arrival in Rome.

On 21 April 1508 Raphael wrote a letter from Florence to his uncle in Urbino asking him to procure him a letter of recommendation: he intended applying to the *signoria* in Florence to decorate one of their chambers (about which nothing is further is recorded). In Florence Raphael's career prospects had improved dramatically, for Michelangelo had left the city and was busy working on the frescoes in the Sistine Chapel in Rome, and Leonardo had moved back to Milan. In the circumstances, Raphael himself seemed surprised to be summoned to Rome. We do not know for certain whether it was in late 1508 or early 1509 that he joined the other artists in the Stanze. At all events, he was certainly there by 13 January 1509, as an entry in the ledger of the Papal Exchequer confirms. He must have

established himself within a very short time, for as early as 8 October 1509 he was accorded the ecclesiastical honorary title of "Brief Writer," which was a sign of his acceptance at the Papal Court and, at the same time, a guarantee of a regular income.

Sodoma had made a successful start to the refurbishment of the Stanza della Segnatura (ill. 51). Hovering cupids hold the keystone of the whole vault with the coat-of-arms of Nicholas V, who built the Stanza, over an octagonal opening in the roof, which allows a clear view of the sky. In order to reinforce this illusion, he selected imitation gold-mosaic for the other pictorial backgrounds on the ceiling. Sodoma received the contract for the ceiling fresco on 13 October 1508.

Segnatura means "signature" and denotes the room's function in the mid-16th century, when the pope used to sign and seal Papal Bulls and Briefs here. Julius II wanted to use it as a private library.

The traditional way of decorating libraries went back to the Middle Ages. Each of the four wall-surfaces was allocated one faculty from the spectrum of knowledge then available: Theology, Philosophy, Jurisprudence, and Medicine. Since the late 15th century, Medicine had been replaced by Poetry.

The decorative work on the Stanza della Segnatura follows the usual pattern, whereby Theology, Philosophy, Jurisprudence (as Justice), and Poetry were presented as female figures. They all appear in four large tondi on the ceiling. Along the walls are allocated to them the appropriate *uomini famosi*, men and women from history who had won fame in each of these fields.

When Raphael began working on the refurbishment of the Stanza della Segnatura, this program of decoration had already been decided. Possibly there were plans for the entire room. Raphael's plans did not alter the overall pattern at all, and yet his new ideas drove all the other artists – including the highly regarded old master, Perugino – out of the Stanze.

We can understand why his work was so successful with the pope if we compare the traditional way in which the *uomini famosi* were depicted in a fresco by Perugino, completed around 1500, with Raphael's famous philosophers, depicted in *The School of Athens*.

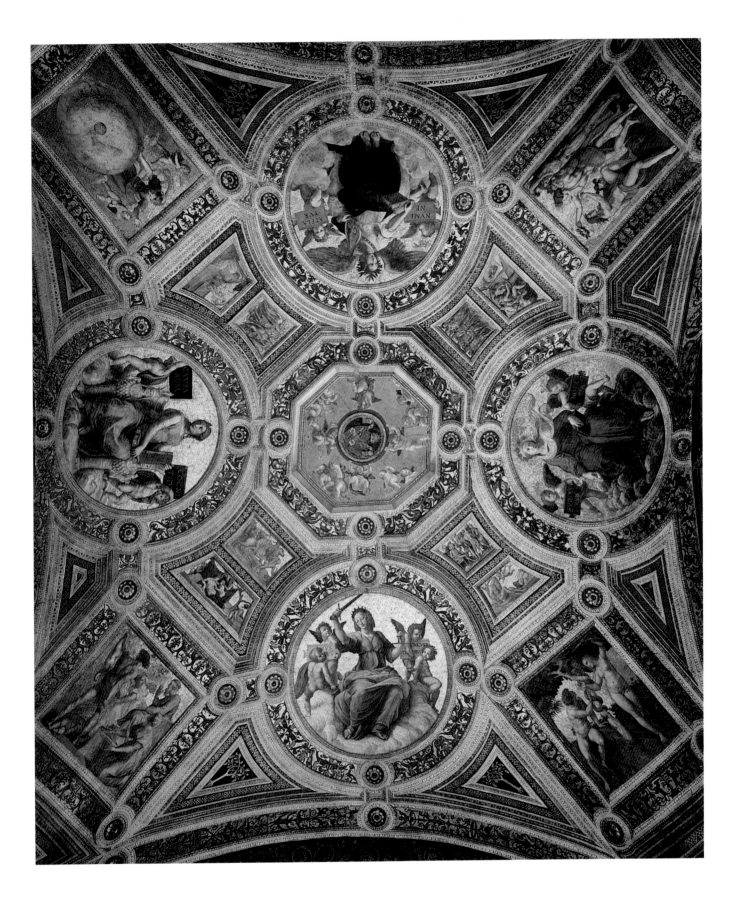

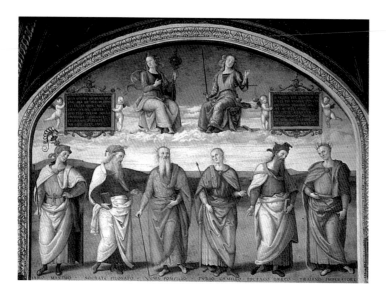

52 (left) Pietro Perugino
The Judicial Virtues, 1499/1500
Fresco
Museo D'Arte Collegio del Cambio, Perugia

Perugino finished painting the frescoes in the Collegio del Cambio, the Money Changers' Hall, in Perugia in 1500. In the arch illustrated, there are two Virtues, each of which has been allotted one Greek and two Roman *uomini fanosi.* Left is Wisdom; beneath her are Fabius Maximus, Socrates, and Numa Pompilius. Right is Justice, and below her are Furius Camillus, Pittacus, and Trajan.

53 (below) *The School of Athens,* 1509
Fresco, width at the base 770 cm
Vaticano, Stanza della Segnatura, Rome

The School of Athens is a depiction of philosophy. The scene takes place in classical times, as both the architecture and the garments indicate. Figures representing each subject that must be mastered in order to hold a true philosophic debate – astronomy, geometry, arithmetic, and solid geometry – are depicted in concrete form. The arbiters of this rule, the main figures, Plato and Aristotle, are shown in the center, engaged in such a dialogue.

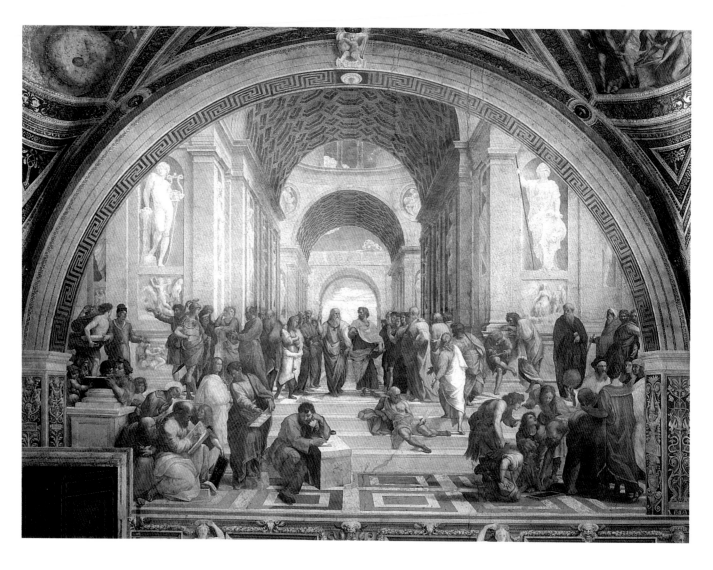

In Perugino's picture the figures are all standing in a line (ill. 52); Raphael, by contrast, portrayed not a row of figures but an event, setting the figures in a context that probably aptly depicts his humanist contemporaries' view of the ancient world (ill. 53).

We do not know if the pope summoned Raphael because he was hoping for an alternative design to the stylistically traditional solution offered by Perugino, though it is quite likely. According to Vasari, it was Donato Bramante who had drawn the pope's attention to Raphael. He and Raphael may well have been related. Furthermore, Bramante was on very good terms with Leonardo, whose *Last Supper* in Santa Maria delle Grazie in Milan had established a completely new pictorial concept; in the 1490s Leonardo was working on his fresco at exactly the same time as Bramante was extending the church. So Bramante was familiar with the latest trends in painting, trends now being practiced by Raphael, and was aware that Perugino's more tender but less dramatic style was a thing of the past.

Leonardo's starting-point was the assumption that all the figures in a painting should play a role in the pictorial event. First of all, he would sketch out the outline composition, in which he depicted the figures as "stick people" to show what they could contribute to the action. If the main figure was telling a story, for example, the story's content should be apparent from the figure's pose, gestures, and facial expressions. Moreover, Leonardo insisted, the reactions of those listening should also match the words of the storyteller. Only when this overall arrangement was sketched out would he paint the individual figures in greater detail, tighten up the composition, and fashion a harmonious picture. By this means Leonardo made his figures not only physically present but also – and above all – involved emotionally. Raphael had learnt this approach to painting during the years both artists had worked in Florence. His preliminary sketches from this period are much freer than his earlier works.

Even today there is still controversy over the order in

54 *Disputa*, ca. 1510/11
Fresco, width at the base 770 cm
Vaticano, Stanza della Segnatura, Rome

The fresco can be seen as a portrayal of the Church Militant below, and the Church Triumphant above. A change in content between a study and the final fresco shows that the *Disputa* and *The School of Athens* (ill. 53) can be seen as having a common theme: the revealed truth of the origin of all things, in other words the Trinity. This cannot be apprehended by intellect alone (philosophy), but is made manifest in the Eucharist.

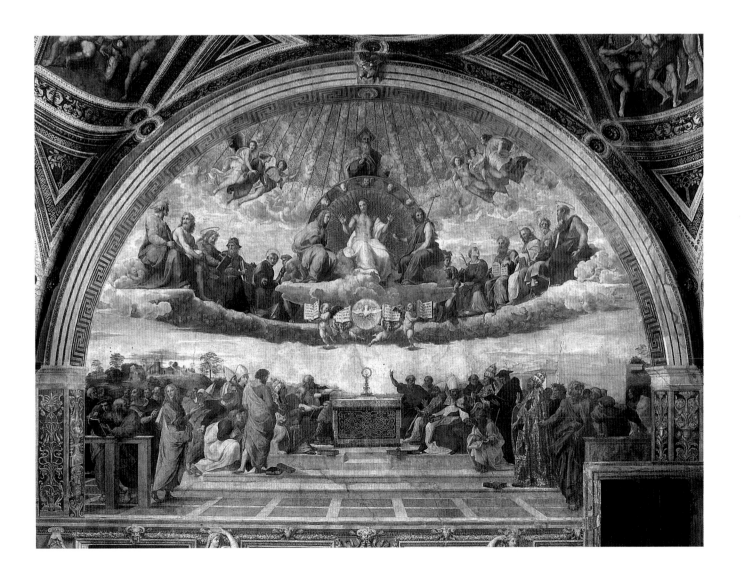

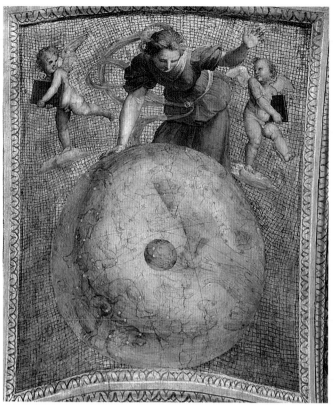

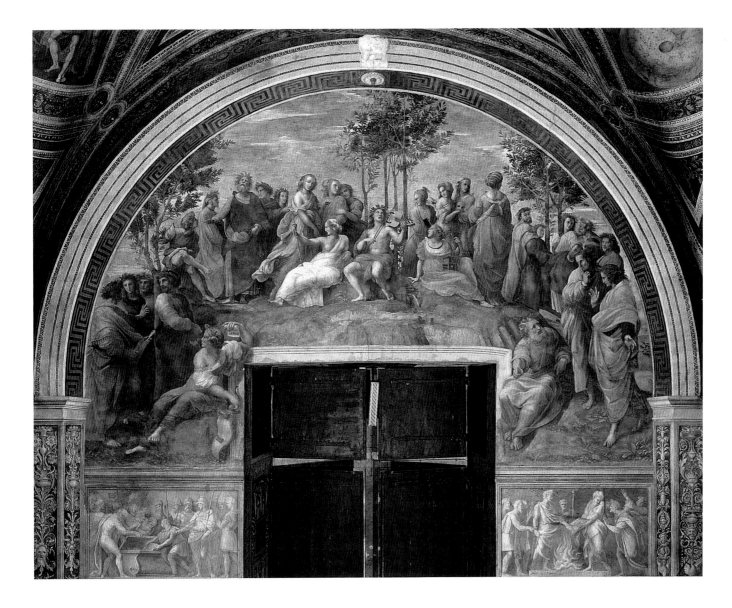

55 (opposite, top left) *The Judgment of Solomon*
(ceiling panel), ca. 1510/11
Fresco, 120 x 105 cm
Vaticano, Stanza della Segnatura, Rome

The story from the Old Testament tells how two women came
to Solomon to settle a dispute about which one was the mother
of a child. When Solomon ordered the baby to be cut in half,
one of the women agreed to give up the child. Solomon
recognized her as the true mother. The man holding the sword
derives from a classical figure, either Castor or Pollux from the
Quirinal, an ancient Roman palace.

57 (opposite, bottom left) *Adam and Eve* (ceiling panel),
ca. 1509–1511
Fresco, 120 x 105 cm
Vaticano, Stanza della Segnatura, Rome

This portrayal of the Fall is generally attributed to Raphael.
Standing in a distinct contrapposto pose, Eve recalls the figure of
Leda in a study by Leonardo da Vinci – Raphael made a drawing
of this while he was in Florence.

56 (opposite, top right) *Prime Mover (Astronomy)*
(ceiling panel), ca. 1509–1511
Fresco, 120 x 105 cm
Vaticano, Stanza della Segnatura, Rome

The figure bending in a beautiful *scorcio* over the celestial globe
is a masterly example of perspective. Philosophically, this figure
can be seen as an allegory of the beginning of the universe, but it
might also be an embodiment of the science of astronomy. The
constellation on the globe can be calculated exactly: the night of
31 October 1503, the date that Julius II was elected pope.

58 (opposite, bottom right) *Apollo and Marsyas*
(ceiling panel), ca. 1509–1511
Fresco, 120 x 105 cm
Vaticano, Stanza della Segnatura, Rome

The shepherd Marsyas had challenged the god Apollo to a
musical contest. Marsyas lost and as a punishment for daring to
challenge a god he was flayed alive. The scene is an allegory of
divine harmony triumphing over earthly passion. With its
unrhythmical composition and its elongated figures, this scene is
probably by an unknown hand, and not by Raphael.

59 (above) *Parnassus*, ca. 1509/10
Fresco, width at the base 670 cm
Vaticano, Stanza della Segnatura, Rome

Mount Parnassus, the home of Apollo is, like the hill of the
Vatican, a place where in ancient times there was a shrine to
Apollo dedicated to the arts. This has a direct bearing on the
picture because through the window on the wall where the
fresco is painted there is a view of the Cortile del Belvedere and
the hill of the Vatican. There were newly discovered classical
sculptures in the Cortile, such as the Ariadne that Raphael used
as a model for the muse to the left of Apollo.

which Raphael completed the frescoes in the Stanza della Segnatura. It seems reasonable to assume that first he finished the compositional sketches for all four walls, as well as the remaining ceiling pictures. He probably painted the four female personifications in the ceiling tondi first. Their monumental appearance suggests the influence of Fra Bartolommeo's work in Florence, and their body rotation that of Leonardo and Michelangelo. Individual motifs like the putti and *genii* recall the predella of the Borghese *Entombment* (ills. 40–42). The unusual way in which Poetry (ill. 64) is supporting her book on her upper thigh is prefigured by the figure of St. Peter in the *Madonna with the Baldacchino* (ill. 50). Later, Raphael completed three of the four rectangular picture areas on the ceiling; the fourth appears to have been painted by an unknown master (ills. 55–58).

"Know the causes" is the Latin inscription on the two tablets held by *genii* on either side of Philosophy (ill. 62).

This is also the theme of the fresco on the wall immediately below Philosophy – the fresco to which, in the 17th-century, the writer on art Bellori gave the now famous title of *The School of Athens*. In the center stand Plato and Aristotle, the two most illustrious philosophers of classical times (ill. 63), immersed in a dialectical discourse. Only this form of discourse can lead to knowledge of causes, since it reveals contradictions and allows arguments for and against a proposition to be expressed. We can identify Aristotle from his book "Ethica" ("Ethics"), whose subject is the proper way for people to behave in this world. Under his arm Plato is carrying the book "Timaios" ("Timaeus"), the dialogue in which he reflected on the nature and the creator of the cosmos. In his "Parmenides" he speculated about the origin of numbers and defined the dialectical "triad" as their fundamental prerequisite: "I can only grasp the one if there is a

60 (above left) *Parnassus* (detail ill. 59), ca. 1509/10

The Florentine poet Dante Alighieri (1265–1321), author of the "Divine Comedy," is here depicted standing behind the classical Greek poet Homer. A preparatory study, now in Windsor, shows the detailed working out of the portraits. For Homer's face, Raphael used as a model a classical sculpture, the Laocoön, that had been discovered just a few years before. It is not known which model he used for Dante.

61 (above right) *Disputa* (detail ill. 54), ca. 1510/11

Dante Alighieri was one of the first humanists and one of the originators of the Early Renaissance. His "Divine Comedy," a verse epic from 1320, was regarded as a theological work in Raphael's time, which is why in the Stanza della Segnatura the poet is included among the famous men of the Church.

second, which is different from the first. This difference between one and two constitutes the third." Plato saw a divine principle in this "triad," which is why Raphael depicts him (ill. 63) pointing upwards – his "triad" could be interpreted as an anticipation of the Holy Trinity, a truth that would not be fully revealed until the coming of Christ (ill. 54).

In the ceiling fresco above *The School of Athens*, Philosophy (ill. 62) is looking towards Poetry (ill. 64), and in the fresco below Poetry sits Apollo (ill. 59). The classical god of music and poetry, Apollo is shown on Mount Parnassus, sitting by the stream flowing from Mount Helicon, the sacred residence of the Muses that is dedicated to the arts. He is surrounded by the nine Muses as well as nine ancient and nine modern poets (ills. 60, 61). Playing a *lira da braccio*, Apollo is gazing upwards, indicating that his arts, music and poetry, are divinely inspired.

The motto accompanying the ceiling figure of Poetry is "Inspired by the Spirit." Her gaze directs the viewer to the figure of Theology (ill. 66), whose right hand is pointing towards the fresco beneath her, on which we

can see the most important fresco in the Stanza, which Vasari called the *Disputa* (ill. 54). Here we are shown something that the ancient world could not know before the birth of Christ – the truth as revealed in the form of the Holy Trinity. The composition divides into two scenes, one above the other. In the lower scene the *uomini famosi* of the Church are in conversation. The central motif here is the Host on the altar, the truth as revealed in our living world. Positioned vertically above the Host (in the upper scene) we can see the dove, the symbol of the Holy Ghost, then Jesus Christ, and above Him God the Father – in other words, the Holy Trinity (ill. 67). Christ is the center of a form known as a deësis, in which the Virgin Mary on His right and St. John the Baptist on His left are interceding for humanity. Sitting on a semi-circular bank of cloud are those saints who directly witnessed the divine revelation, and from whose successors the Church was founded. As we have seen, Plato had anticipated the notion of the Trinity: the Christian doctrine of Salvation, in other words, had a precursor in classical philosophy. At this point the whole meaning of the room becomes clear: as Vasari observed,

62 *Philosophy* (ceiling tondo), ca. 1509–1511
Fresco, 180 cm in diameter
Vaticano, Stanza della Segnatura, Rome

The woman enthroned is enveloped in a garment that has four colors, each of which represents one of the four elements, which in turn are symbolized by their pattern. Blue is for the stars (air), red is for the tongues of flame (fire), green is for the fish (water), and golden brown is for the flora (earth). Philosophy holds two books with the titles "Morals" and "Nature," while two *genii* hold texts with Cicero's words *Causarum Cognitio* ("Know the Causes"). This picture is situated above *The School of Athens* (ill. 53).

63 (opposite) *The School of Athens* (detail ill. 53), 1509

Plato and Aristotle are standing in the center of the picture at the head of the steps. Diogenes is lying carefree on the steps to show his philosophical attitude: he despised all material wealth and the lifestyle associated with it. Below on the right is a great block of stone whose significance is probably connected with the first epistle of St. Peter. It symbolizes Christ, the "cornerstone" which the builders have rejected, which becomes a stumbling block and a "rock of offence" to the unbeliever.

64 (right) *Poetry* (ceiling tondo), ca. 1509–1511
Fresco, 180 cm in diameter
Vaticano, Stanza della Segnatura, Rome

The lyre and the laurel wreath are the symbols of Poetry, who here appears as a winged figure. Like Aristotle in *The School of Athens*, she is holding a book in an unusual way; the title is not known. Two putti are holding the tablets on which are written the words of the Roman poet Virgil's, "Numine Afflatur" (Inspired by the Spirit). The Christian "spirit" is meant here, since putti are holding the text and not *genii*, as with the figure of Philosophy.

65 (below) Cartoon for *The School of Athens*, 1509
Black chalk and charcoal, 275 x 795 cm
Pinacoteca Ambrosiana, Milan

This, the largest surviving cartoon of the early 16th century, consists of 195 single pages that make up the lower half of *The School of Athens* in the original size. The cartoon itself was not used to transfer the composition onto the wall; instead, smaller intermediary cartoons that were easier to handle were put together for this purpose.

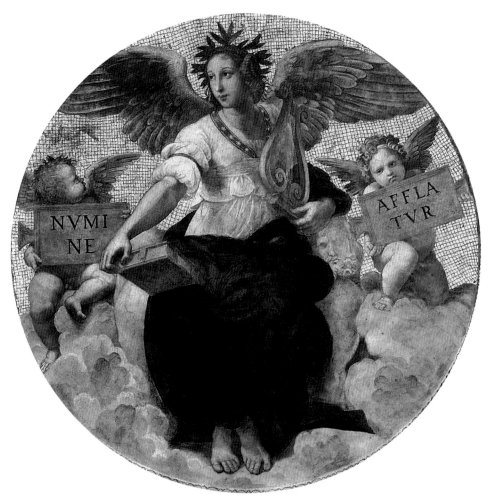

66 *Theology* (ceiling tondo), ca. 1509–1511
Fresco, 180 cm in diameter
Vaticano, Stanza della Segnatura, Rome

Theology's veil is white, her cloak green, and her dress
red, the colors of the theological Virtues (Faith, Hope,
and Charity). She is holding a book in her left hand and
is pointing with her right hand at the fresco of the
Disputa below. Two putti are holding blue tablets with the
golden inscriptions *Divinar. Rer* and *Notitia* ("Knowledge
of Divine Things").

67 Study for the *Disputa,* 1509
Brush and white highlighting over stylus underdrawing,
28 x 28.5 cm
Windsor Castle, Royal Library, Windsor

The earliest idea for representing the *uomini famosi* for
the *Disputa* was the visual portrayal of the "living rocks"
on which the Church was founded. Raphael found the
design unsatisfactory because there was no way of
depicting the link between the *uomini famosi* and the
most important motif of the entire program, the truth
revealed in the form of the divine Trinity in heaven. His
problem was solved by the additional symbolic portrayal
of this central theme in the form of the Host on the altar.

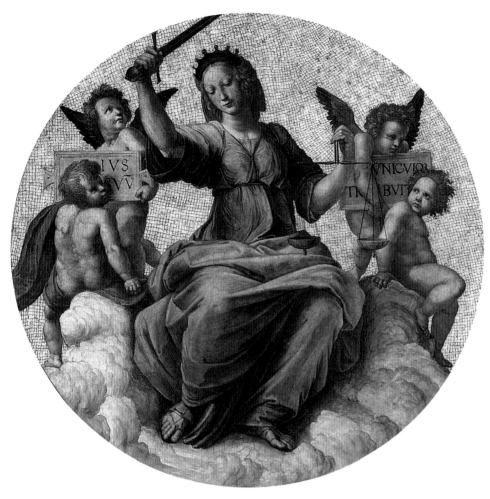

68 *Justice* (ceiling tondo), ca. 1509–1511
Fresco, 180 cm in diameter
Vaticano, Stanza della Segnatura, Rome

The personification of Justice is holding, as her symbols, weighing scales and a sword. Her eyes are directed at the fresco below, *The Virtues* (ill. 69), in which Fortitude, Wisdom, and Temperance are portrayed in the form of three women. Taken together, all four personifications represent the Cardinal Virtues. Justice's prominent position is explained by the fact that Justice was said by Plato to play a decisive role among the virtues. Two putti are holding the inscription with the words of Emperor Justinian, "She gives Justice to all."

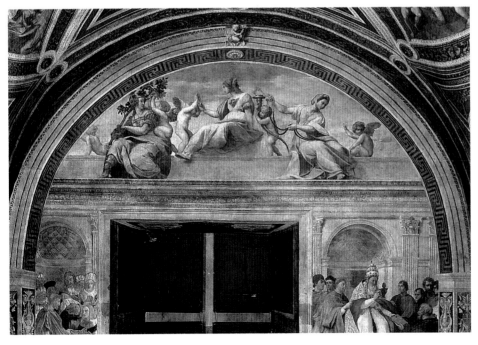

69 *The Virtues*, 1511
Fresco, width at the base 660 cm
Vaticano, Stanza della Segnatura, Rome

Fortitude can be recognized by her attribute, the lion; Wisdom, who has two faces, by her mirror; and Temperance by the reins. Fortitude is holding an oak branch, a reference to the pope's family name, Rovere, meaning "oak."

here the ancient world and Christianity are brought together in harmony.

The personification of Justice (ill. 68) leads us into the period following the Incarnation of Jesus. She is looking down towards the lunette where there are three other personifications who, together with her, represent the four Cardinal Virtues, namely Fortitude, Wisdom, and Temperance (ill. 69). On the wall allocated to Justice we see only two *uomini famosi*, each of whom appears in a scene of his own. These scenes depict the handing over of important documents relating to the history of Civil and Canon (Church) Law. Emperor Justinian, a temporal ruler, presents the Pandects (a compilation of Roman laws) to the jurist Trebonianus (ill. 70), whilst Pope Gregory IX accepts the Decretals (a codification of Church law) from St. Raymond of Penaforte (ill. 71). This form of depiction had some compositional advantages, for here the wall space was broken up by a large off-center window.

In order to realize the basic concept of his program

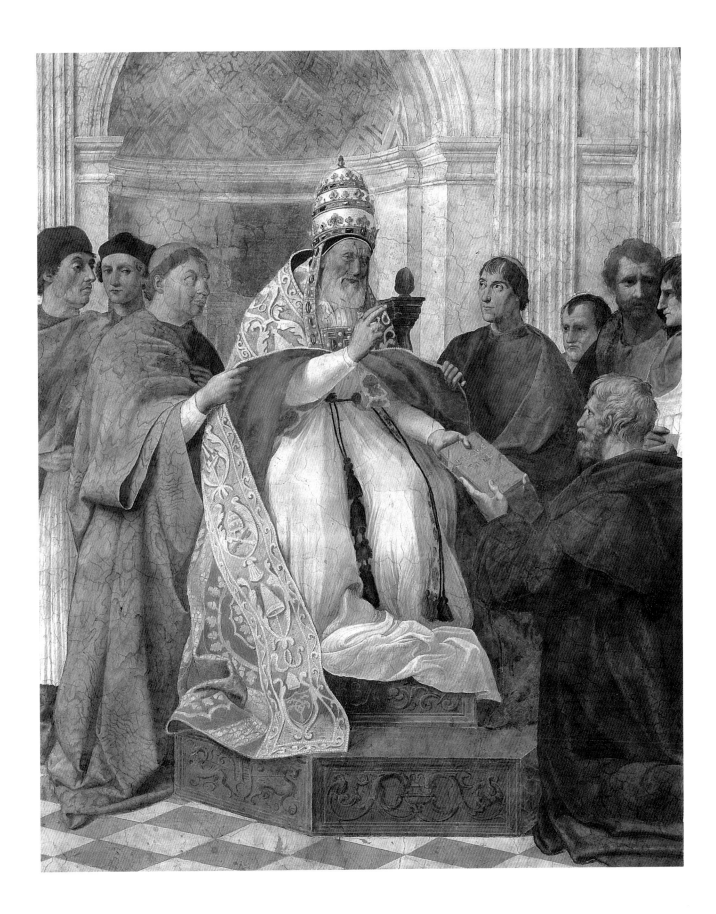

for the Stanza della Segnatura, which was to show the *uomini famosi* in conversation, Raphael needed to know more about these people than simply their names and symbols. To achieve this he had to consult a humanist who could not only answer his questions clearly but who also had a feeling for what was relevant to a painting. We now believe that this person was the poet and librarian Tommaso Inghirami (ill. 85). At the very least, he played a role in developing the program of the *Disputa*. We find Inghirami's portrait in *The School of Athens* – he is on the left, where, crowned with a laurel wreath, he stands writing behind a broken column.

The School of Athens (ill. 53), the theme of which is dialectical discourse, is aptly named. The Athenian philosopher Socrates, who was Plato's teacher, speaks of the four steps which a pupil must climb in order to conduct a philosophical discussion. They are: geometry, astronomy, arithmetic, and solid geometry. With this in mind, Raphael has depicted four steps leading to a monumental hall. Socrates, who is standing next to Plato on the left, with some other pupils, is counting what we may assume are those four steps on his fingers. Holding a celestial globe, the astronomer, Zoroaster, is standing at the bottom right, talking to the astronomer Ptolemy, who is holding a disc of the earth (ill. 73). Alongside him, geometrician Euclid is explaining a star-shaped geometrical figure to his pupils. On the left sits Pythagoras, the arithmetician; he appears to be copying something about the theory of musical harmony from a tablet which a pupil is holding in front of him (ill. 74). Only solid geometry cannot be linked to any named individual. The man who is resting his elbow on the large block of stone was added later, after the fresco was completed. Art historians like to identify him as Michelangelo. Here, it is supposed, Raphael was paying homage to the master of the Sistine Ceiling, whose style this figure reflects. The art historian Matthias Winner, however, has suggested a much more plausible explanation for this later addition. For Winner, the stone block representing solid geometry can be interpreted differently.

Pope Julius II seems to have been fond of the metaphor of "living rock" as the origin of the Church. This goes back to the First Book of Peter, in the New Testament. There, Christ is described as the "cornerstone" who is "precious unto you … which believe" but "a stone of stumbling, and a rock of offence, even to them which stumble at the word." Raphael did indeed depict a cornerstone, as we can clearly see from its fine moldings.

Raphael built up his compositions in the Stanza della Segnatura symmetrically. This allowed him – in *The School of Athens*, for instance – to arrange groups to the left and the right of the central figures as independent units, as a kind of *Sacra Coversazione*. Intermediate

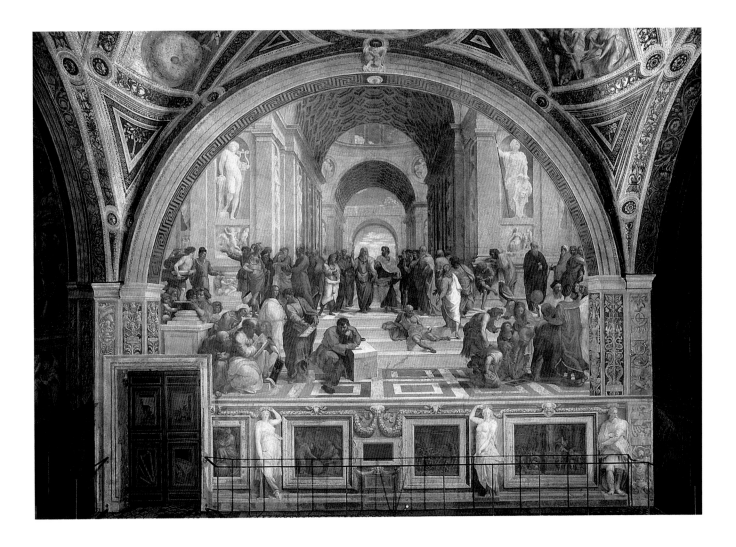

figures link these groups by means of gestures, move-
ments and glances, so that the impression of a large,
lively school of philosophy is created.

An architectural backdrop – which prefigures future
set designs – provides the background. Vasari believed
this had been designed by Bramante, and it is certainly
true that such an architectural backdrop is scarcely
conceivable without his influence. However, Raphael
could well have designed it, for even in his earlier works
he had displayed a thorough knowledge of the principles
of pictorial architecture. Figures are pressing into the
picture from right and left, creating the convincing
impression of an inhabited architectural space; some
figures are leaning against the walls. With a minimum
of motifs, Raphael succeeds in blending the background
architecture harmoniously into the pictorial whole.

Deep in debate, Plato and Aristotle are striding
towards us from the depths of a majestic hall. Both
figures, though, have been composed like standing
sculptures, and only Plato's hesitant step and Aristotle's
forward-pointing gesture give any indication of move-
ment. It is in fact the architecture that gives the figures
a sense of movement. The semi-circle of the archway in
the far distance, which frames the two figures, is echoed
rhythmically in semi-circles of ever increasing size,
creating a sense of movement which is transferred to
these two main characters. It was compositions of this
kind that convinced the pope of Raphael's abilities.
According to Vasari, the pope decided to dispense with
frescoes by other artists in order to allow Raphael full
scope to develop his program.

Even so, Raphael did not rest on the laurels he had

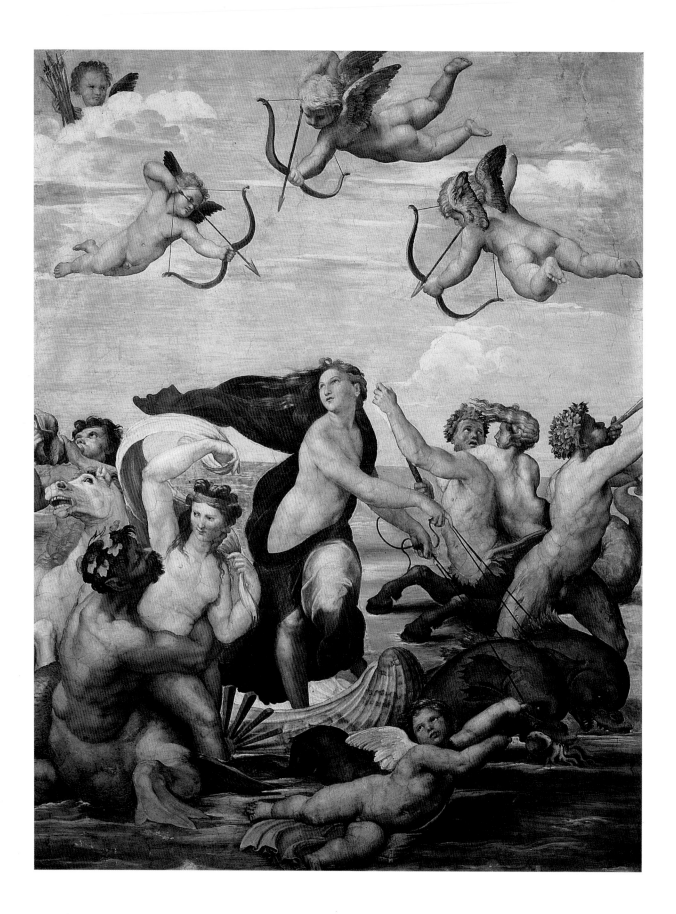

77 (above) *The Triumph of Galatea* (detail ill. 76), 1511

This putto's pose recalls that of the boy Jesus in Michelangelo's *Taddei Tondo* dated 1502, now in London.

76 (opposite) *The Triumph of Galatea*, ca. 1511
Fresco, 295 x 225 cm
Villa della Farnesina, Rome

The Sienese-born banker Agostino Chigi had his villa in the Roman quarter of Trastevere decorated with themes from mythology featuring female figures of virtue. The Nereid Galatea is praised in a poem by the Florentine scholar Politian because she chooses spiritual over physical love when she spurns the advances of Polyphemus. The latter is depicted in a fresco by Sebastiano del Piombo, which stands to the left of Raphael's *Galatea*.

won from his work on the Stanza della Segnatura. On the contrary, he remained just as willing to learn, took up new subjects, and developed old ones further. Nevertheless, he retained his clear symmetrical layout, which had been so successful, as a compositional principle. This form allowed him to achieve a monumental overall effect which was easy to grasp, and also created an ideal framework for his style of composition, which was based on contrasts.

The commission for the pope had alerted all Rome to the young artist, and notably a wealthy banker, Agostino Chigi, a friend of Julius II. Chigi commissioned Raphael to decorate the ground floor of his newly-built villa with a mural featuring the sea-nymph Galatea (ill. 76). This nymph was the first classical subject Raphael had painted since *The Three Graces* (ill. 16).

The basic design is both simple and 'ambitious.

Galatea is the main figure. For her, Raphael once again employed the *figura serpentinata*, depicting her amid a turbulent mass of bodies twisting and turning in the water, a few elegant cupids hovering above. The overall composition is dominated by an exciting rhythm, created by movement and counter-movement, with Galatea's red robe its triumphant focus.

Galatea is surrounded by a storm of physical temptation – naked bodies, passion, noise, tumult, and lust. She is indifferent to it all, her tender gaze seeing only to the Cupid of Platonic love, who is sitting up above, his arrows still in his quiver. Standing in a shell, Galatea races through the water, remarkably calm considering the violent movement of the dolphins pulling her. Despite this inconsistency, Raphael created a harmonious and at the same time lively painting of incredible charm.

MICHELANGELO AND RAPHAEL
IN COMPETITION

For Raphael as a young artist in Florence, Leonardo and
Michelangelo were at the same time models and teachers.
At this point, the two older artists were locked in rivalry,
since both of them had been commissioned to design battle
scenes for the Palazzo Vecchio (Town Hall) in Florence. As
yet, Raphael was no competition to either. All his life he held
Leonardo in high regard (ills. 78, 79). Over the next few
years, however, Michelangelo turned out to be a serious
opponent in both artistic and financial matters. They met
as rivals in Rome, for both were seeking the favor of Popes
Julius II and Leo X in order to win important commissions
at the papal court.

A letter Michelangelo sent a cardinal as early as 1542
expresses his bitterness over his young rival: "All the bad
blood between Pope Julius and me was due to envy on the
part of Bramante and Raphael of Urbino … They wanted to
ruin me, and Raphael had good reason, for everything he
knew about art came from me."

Referring to Raphael's fresco *The Prophet Isaiah* (ill. 80)
in the church of Sant'Agostino, Vasari claims that the
architect Bramante secretly took Raphael, his relative from
Urbino, to see Michelangelo's frescoes in the Sistine Chapel
when Michelangelo was away from Rome. This experience,
Vasari continues, enabled Raphael to improve his own style
of painting and to give his figures far more grandeur and
dignity (ill. 81). Exactly these qualities were required for the
1512 commission in Sant'Agostino, when Raphael had to
hold his own against the sculptor, Sansovino, whose
sculpture group depicting St. Anne with the Virgin Mary and
Christ Child was to be erected beneath Raphael's fresco.
Unlike Vasari, Paolo Giovio, the humanistically educated
first biographer of Raphael, warmly praised him for being
open to useful influences. Humanists admired Raphael's
ingenuity, an ingenuity that brought Michelangelo a
crushing defeat shortly after his former rival had died.

Buonarroti had applied to Leo X through Sebastiano del
Piombo, an artist with whom Michelangelo was on friendly
terms, to decorate the Sala di Costantino in the Vatican.
However, despite the great success of his work on the
Sistine Chapel, Michelangelo was rejected on the grounds
that Raphael's pupils already had their master's designs, and
it was these that would be painted.

Leo X attached great importance to the new decorative
scheme in the Sala di Costantino for it was meant to confirm
the Church's legitimate claim to secular territory. The whole
subject had been explosive since the mid-15th century, for
the papacy – like the whole Vatican State – was founded
on a gift of Emperor Constantine, who was said to have
granted the Eternal City to the papacy. Raphael's design
satisfied the interests of Church politics, which were
undoubtedly in the forefront of Leo X's mind. In other
words, the main concern here was not which great master
painted the frescoes (ills. 82, 83). Nevertheless, the pope
probably did not in fact consider Michelangelo as inventive
as Raphael. "When I had looked at the total design for *The
Last Judgement* by Buonarroti I began to understand
Raphael's famous gracefulness and the appealing beauty of
his inventiveness." This remark by the writer Aretino, which
he made in a letter of 1545, could have come just as easily
from the Pope himself.

It was not until the following centuries that
Michelangelo's status as a great artist was fully appreciated.
This assessment was first expressed in a funeral address
which the writer, Benedetto Varchi, made at Michelangelo's
graveside. He said that Raphael of Urbino would have been
the very greatest of painters – if Michelangelo Buonarroti
had not existed. Nowadays, Michelangelo and Raphael are
both regarded as exceptional figures in a period remarkable
for its outstanding cultural achievements, the Renaissance.

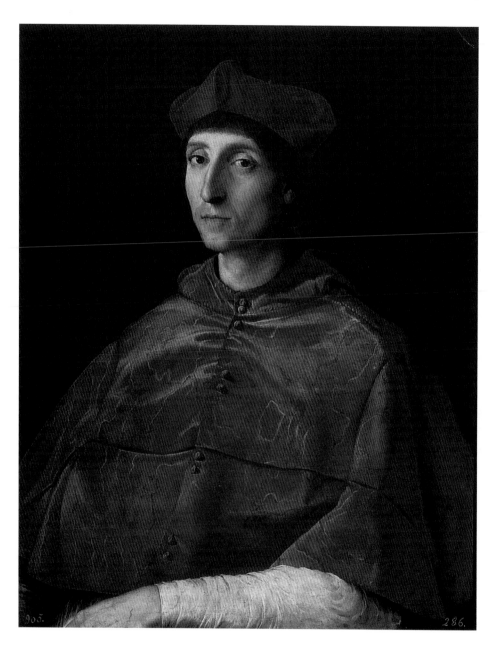

"We have to admit that Raphael was the superior artist
in the painting of eyes and capturing the liveliness of a
look." So concluded a comparison between Raphael and
Michelangelo written in 1625 by Cardinal Federico
Borromeo, founder of the Biblioteca Ambrosiana in
Milan. The Madrid *Portrait of a Cardinal* (ill. 84)
appears to bear out Borromeo's words. We see the
dignitary seated in three-quarter profile against a dark
background. His upper body is not turned towards
us, though his eyes gaze at us all the more directly.
The Cardinal's right eye is particularly striking in its
rhythmic line, its three-dimensional modelling, and its

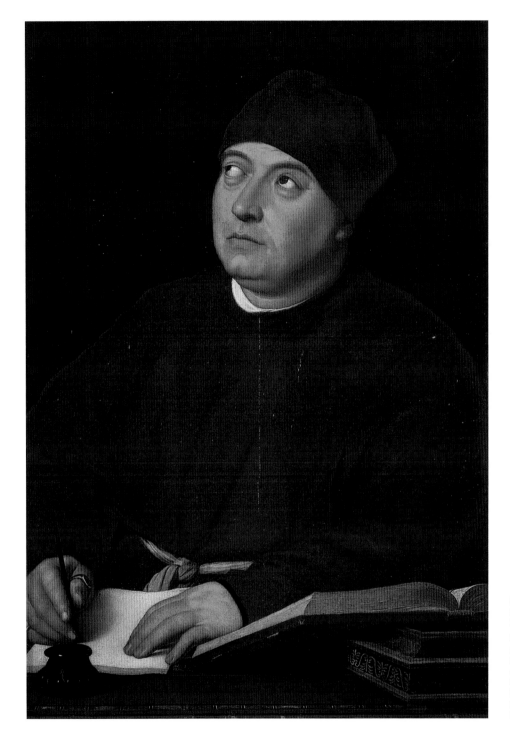

85 *Portrait of Tommaso Inghirami,* ca. 1511
Panel, 89.5 x 62.3 cm
Palazzo Pitti, Galleria Palatina, Florence

It is assumed that the poet and librarian Inghirami
worked with Raphael on the program of the Stanza della
Segnatura. There is another, almost identical version of
this portrait in Boston, which came from the Inghirami
family home in Volterra. The alterations in that painting,
however, compared with the underlying drawing, suggest
that the panel in the Galleria Palatina is the original by
Raphael himself.

clear expression. The convex shape of the eyeball is
clearly defined in its socket, the eyelid coming down
at a slight angle over the moistly gleaming pupil.
The sitter's gaze is so direct it is difficult to meet it.
This unknown figure was probably one of the more
important people in the papal court, for his portrait –

with the same penetrating look – is to be found in on
the left-hand side of the *Disputa* (ill. 54).

In this portrait, with its captivating colors, Raphael
was once again trying to achieve a design rich in
contrasts. The finely folded material of the sleeve,
painted in broken white, forms the base on which the

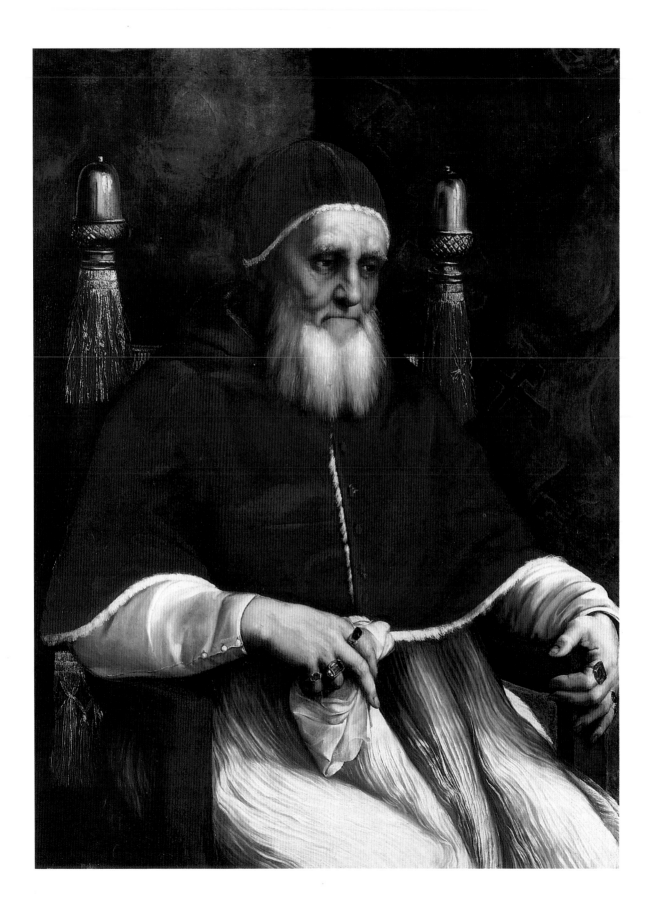

portrait bust is set. In its fluid softness this material forms a stark contrast to the stiff, heavy *mozzetta*, the cape worn by high dignitaries of the Church, and emphasizes its heaviness. This red fabric rises like a pyramid, and, together with the glowing red of the cap, frames the pale, cool skin of the gaunt subject.

The detail of Raphael's depiction directly recalls the Doni portraits (ills. 26, 27), though now the conception is freer, the light softer. This portrait also reveals his increasing skill in rendering detail in a life-like way.

At about the same time as he painted this early Roman portrait, Raphael also completed the portrait of Tommaso Inghirami (ill. 85). This scholar and poet was appointed Prefect of the Papal Library in 1510, and it is presumably from this period that the portrait, now in Florence, dates. As a close examination of the panel has shown, a green curtain originally formed the background. Raphael appears to have abandoned this in favor of the same kind of dark background he used for the portrait of the unknown cardinal (ill. 84). Despite this similarity between the two paintings, Raphael used a completely different approach in the Inghirami portrait. He portrayed the poet in a small pictorial narrative, depicting the intimate moment at which the scholar, sitting at his desk, is awaiting divine inspiration. His right hand holds his pen expectantly, while his left hand rests on a blank sheet of paper. An open book confirms that he is a scholar.

The idea of showing an author being divinely inspired dates back to classical times. In his interpretation of this theme, Raphael once again focused on the subject's eyes. In the process, he achieved a real feat, for Inghirami had a severe squint. Raphael depicted this defect honestly, and yet it is not in the least disturbing because the scholar's look, directed upwards and to the left, can be seen positively, as his search for inspiration. This subterfuge doubtless assured Raphael of his patron's approval – and that of the scholar's humanistic friends. It would also have earned the approval of Pliny the Elder, the classical writer whom humanists were fond of quoting. Pliny had praised the ancient Greek painter Apelles for inventing a technique that enabled an artist to conceal any physical defects in the subject of a portrait. Apelles painted King Antigonus in such a way that it was not possible to see that he had only one eye. In his picture, Raphael made it more difficult for himself by showing both his subject's eyes, yet he was able to avoid any hint of a disturbing impression by ingeniously making the subject look for inspiration.

Here, too, Raphael developed a convincing pictorial space for the figure. Inghirami's stout body occupies its place behind the table in an imposing way. His right arm and hand are foreshortened to brilliant effect, and cover the full depth of the pictorial space in the foreground. The figure's sculptural three-dimensionality and the varied play of light and shade in the skin tones establish a direct link with the earlier *Portrait of a Cardinal* (ill. 84). A delicate glazing technique distinguishes both portraits, and this suggests that Raphael painted both immediately after his Florentine portraits, in other words during his first years in Rome.

When Julius II commissioned Raphael to paint his portrait, it must have been both an honor and a burden. How could he possibly surpass the portraits of the cardinal and Inghirami, both of which the pope undoubtedly admired? Raphael solved this problem by combining the two aspects of these portraits he had developed to such advantage: a clear emphasis on both expression and action (ills. 86, 87).

A private audience provides the portrait's context. Raphael has shown us to a standing place, as protocol would demand, while the pope remains seated. The papal chair, whose backrest finials are crowned by the acorns from the della Rovere coat-of-arms, is presumably standing on a small pedestal; and behind the chair are emerald-green hangings bearing the papal coat-of-arms, crossed keys. Julius is calm and dignified. Audience means "listening," and that is exactly what the pope appears to be doing. He is looking at someone whom we cannot see, but who seems to be kneeling in front of him, his gaze open but critical, as if reflecting on what he has just heard. This makes his strong grip around the left-hand armrest look all the more powerful, while in complete contrast his right hand is holding a soft piece of cloth almost playfully. As in other Raphael paintings, a window is reflected in this picture – this time in the golden acorns of the finials. Even in his portraits, Raphael's central concern was with a picture's artistic effect, as another detail confirms – he has quite clearly moved the chair finial on right to ensure that the pope's face is clearly delineated.

In a subtle interplay of look and gesture, Raphael communicates the contrast between the venerable pope's age and his historically documented energy. This, together with Raphael's depiction of precious materials,

87 (right) Raphael's Workshop
Portrait of Pope Julius II, ca. 1512
Panel, 108.5 x 80 cm
Galleria degli Uffizi, Florence

This portrait of Julius II as an old man was long thought to be the original Raphael, but a thorough investigation of the London painting has proved this view wrong. The version in the Uffizi is now said to be from Raphael's workshop, much to the annoyance of the Italians. Another version of the portrait in the Palazzo Pitti has been attributed to Titian by some experts.

86 (opposite) *Portrait of Pope Julius II,* ca. 1512
Panel, 108 x 80 cm
The National Gallery, London

Pope Julius II gave this painting to the church of Santa Maria del Popolo, where after his death it was displayed on important feast days. In 1591 Cardinal Sfondorato sold it to Scipione Borghese. Its provenance until its acquisition by The National Gallery in 1824 is also documented, so that it can be said with certainty that the London picture is authentic, despite the many other existing versions.

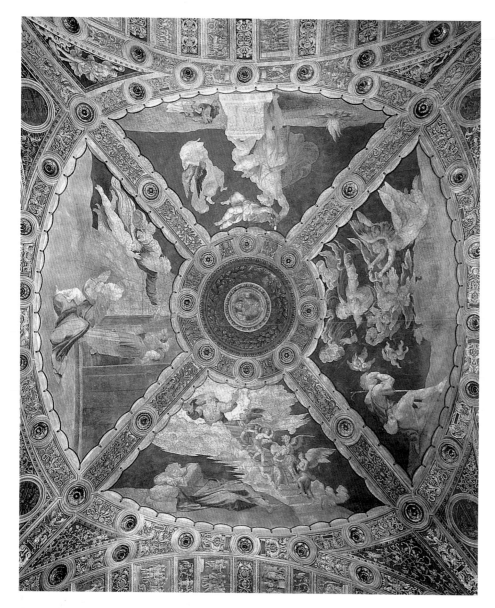

88 Ceiling of the Stanza di Eliodoro, ca. 1513/14
Vaticano, Stanza di Eliodoro, Rome

The four great paintings on the ceiling show scenes from
the Old Testament, the theme being God's intervention at
a critical moment in Man's destiny: *Moses and the Burning
Bush* is above the fresco *The Expulsion of Heliodorus*; *Isaac's
Sacrifice of his Son* is above *The Mass at Bolsena*; *Noah's
Dream* is above *The Repulse of Attila*; and *Jacob's Ladder* is
above *The Freeing of Peter*.

and his magnificent color harmonies, created by the
velvet red, emerald green, and variations of white with
gold highlights, make this a portrait worthy of a pope.
Even though nowadays photography has made us
familiar with realistic portraits, we can still agree with
Vasari when he says that Raphael portrayed the pope
"with so much realism and truth to life that when
standing before the picture you have the strange feeling
it might be alive."

The frescoes in the Stanza della Segnatura had
established Raphael as a court painter. His next com-
mission, the decoration of the Stanza di Eliodoro, on
which he worked from 1511 to 1514, confirmed his
reputation in a very impressive way. The name of this
room is derived from the fresco which Raphael painted

first: *The Expulsion of Heliodorus* (ill. 89). The program
for this room was not a traditional one: the subjects were
developed specifically for this room and for Julius II
personally. The general theme is that of God's
intervention in human destiny, and it is presented
through four stories, two from the Acts of the Apostles
and the Apocrypha, and two from Church history. The
room's ceiling was painted by Peruzzi and his assistants
(possibly to designs by Raphael), about 1514. Here, four
thematically corresponding scenes from the Old
Testament are presented (ill. 88). The subjects of the
previous frescoes have not come down to us.

The pope intended to use this room as a private
audience chamber. Accordingly, the frescoes were meant
to illustrate the power of the Church and its

representatives. The subjects are the Church's four enemies: those who affront the dignity of the Church, those who threaten the Church and the whole of Christendom, those rulers who do violence to the Church's representatives, and finally those within the Church whose faith is weakened by doubt. The program was so general that a contemporary onlooker could well have recognized ecclesiastical opponents of the day, especially when Julius II himself appears in the scenes.

The opening scene, *The Expulsion of Heliodorus* (ill. 89), shows how the prayer of Onias, the High Priest, is heard, and Heliodorus, the Syrian occupier of Jerusalem, intent on plunder, is driven from the Temple by divine intervention. This scene could be interpreted as the pope's warning to the French forces who formerly occupied parts of the Vatican State.

For Raphael these scenes represented a new artistic challenge. The task was to depict historical scenes depicting events that followed each other chronologically, even though a painting can show only one event at a time. Raphael's solution was to use the technique of simultaneous narration, which allows an artist to depict several successive events in a single picture. So in *The Expulsion of Heliodorus* we see both the prayer of High Priest Onias, and, alongside that, the expulsion of Heliodorus.

Julius II appears, as a witness to the events. By directing his gaze towards the High Priest in the pictorial center, he helps the viewer to follow the events in the correct chronological sequence, and at the same time draws the viewer's attention to the power of his office, represented here by an Old Testament High Priest. Chronologically, the scenes follow one another in the familiar "reading direction" of left to right. This makes Julius II seem like a viewer within the picture, the kind of figure the art theorist Alberti, in his famous treatise on painting, demanded for historical pictures. Once the viewer had been introduced to the scenes in this way, Heliodorus' highly dramatic punishment by a rider in golden armor and the two hovering youths in the right-hand half of the picture hardly needed further explanation.

89 *The Expulsion of Heliodorus,* ca. 1512
Fresco, width at the base 750 cm
Vaticano, Stanza di Eliodoro, Rome

In his depiction of the rider and the two hovering youths who expel the Syrian invader Heliodorus from the Temple, Raphael follows the text from Maccabees in the Apocrypha exactly. The horse owes a debt to Leonardo's design for the *Battle of Anghiari* in the Palazzo Vecchio in Florence.

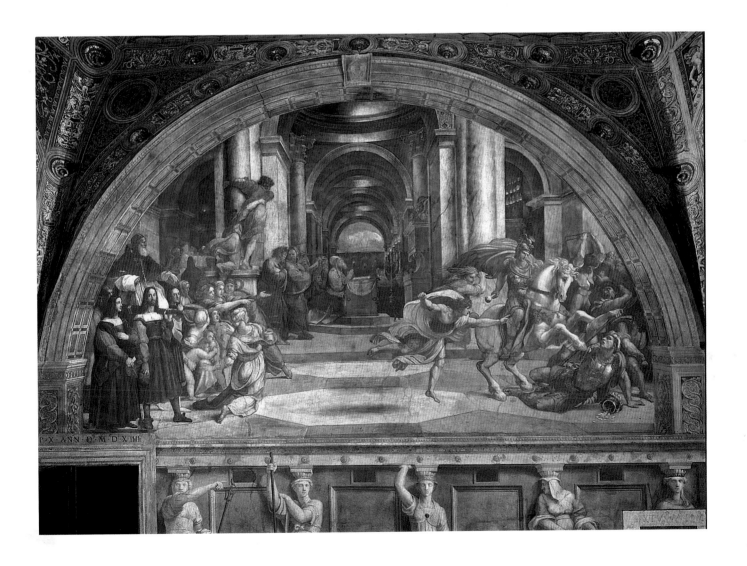

90 (opposite) *The Expulsion of Heliodorus* (detail ill. 89), ca. 1512

Raphael's depiction of the Pope Julius II in the fresco is as penetrating as the London portrait of Julius (ill. 86). According to Vasari, the reason Raphael was so well-liked was probably because he portrayed so many people at the papal court to their satisfaction in these frescoes.

91 (right) *The Mass at Bolsena* and *The Repulse of Attila*, 1512–1514
Vaticano, Stanza di Eliodoro, Rome

This picture shows the window that Raphael had to take into account in the composition of *The Mass at Bolsena*. It also clearly shows the dado of the Stanza, which is decorated with grisaille paintings of eleven caryatids and four hermes. These are now attributed to Perin del Vaga.

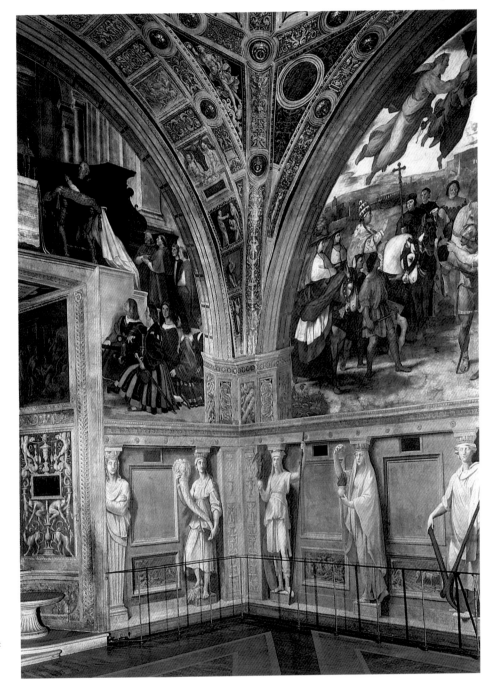

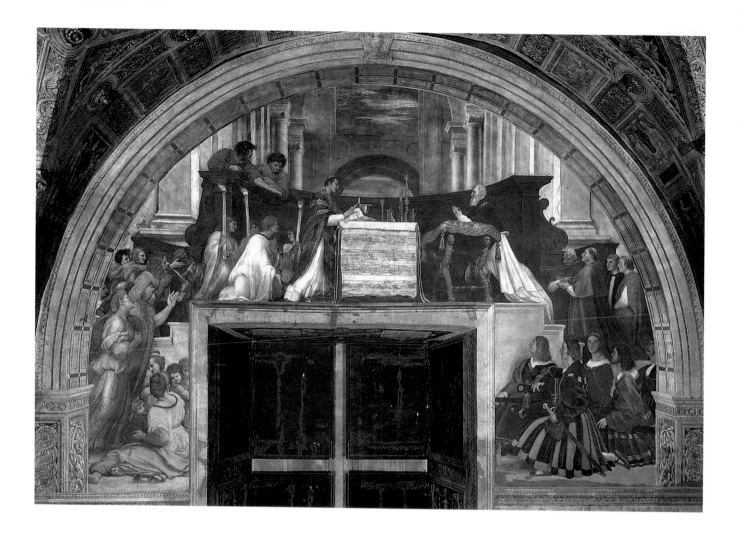

Raphael placed the altar with the praying High Priest in the pictorial center, the vanishing point towards which the perspective lines of the spatial structure converge. The dramatically lit domes and the octagonal floor-slabs, which match the shape of the altar-base, recede rhythmically towards the priest and create a counter-weight both to the dramatic scene on the right and to Pope Julius II on the left.

Here, for the first time, Raphael separated the historical figures who actually took part in the event from those figures of another period who witness its re-enactment – taken together, they depict two different planes of reality in one and the same setting. Traditionally, artists had often brought together people from different epochs in the same spot at the same time. The *Sacra Conversazione* is based on this principle, and Raphael's *Disputa* (ill. 54) follows the same pattern. In *The Expulsion of Heliodorus*, in contrast, those who participated in the past events belong to a different sphere from the pope with his retinue, the present-tense witnesses of those past events. Portraits, figures grouped in pyramid form, heavy fabrics and strong colors all

distinguish the pope's retinue from the historical figures, who, painted in pastel tones, are swathed in flowing garments and performing dramatic gestures (ill. 89).

An off-center window opening made the second scene, *The Mass at Bolsena*, difficult to design (ill. 91). Raphael's ingenious solution was to paint a flight of steps leading up to a high platform, thereby incorporating the window opening into the picture and creating a symmetrical composition. On this platform, towards which we look up as if it were a real architectural detail, stands, in the very center of the picture, the altar on which the miracle of the Mass at Bolsena takes place (ill. 92).

To Julius II, the veneration the Host was a personal concern. In order to make this clear, he himself takes part in the event he is witnessing, kneeling bare-headed at the altar, his hands clasped in prayer (ill. 93). A Bohemian priest, also kneeling at the altar, looks in astonishment at the Host in his left hand, whilst in his right hand he holds a cloth on which several blood-red crosses can be seen. A semi-circular wooden parclose stands behind the altar, creating an intimate space for

92 *The Mass at Bolsena,* 1512
Fresco, width at the base 660 cm
Vaticano, Stanza di Eliodoro, Rome

In 1263 a Bohemian priest, troubled by doubts about the doctrine of transubstantiation (the belief that the body and blood of Christ are present in the Eucharist), started out on a pilgrimage to Rome. On his way he celebrated mass at Bolsena, and during the consecration the Eucharist began, miraculously, to bleed. Each time he wiped the blood away with a cloth a cross of blood would reappear on the Host, a miracle that swept away the priest's doubts. The cloth became a venerated relic and was later kept at Orvieto Cathedral.

93 (opposite) *The Mass at Bolsena* (detail ill. 92), 1512

As in *The Expulsion of Heliodorus,* Raphael here made Julius II a witness of a miracle that took place in the past. On 7 September 1506 Julius had stopped at the cathedral at Orvieto to see the relic of the cloth that was used to wipe the blood from the Eucharist, and thereby to demonstrate his personal connection with the miracle for which Urban IV had instituted the Feast of Corpus Christi.

94 *The Mass at Bolsena* (detail ill. 92), 1512

Julius II had founded the Swiss Guard as a military elite in May 1510, and granted them the distinction of their own costume. The Guard had played a vital role in a victory over French forces, who had occupied parts of the Papal State. The pope was probably bestowing an honor on them for that loyal service by letting Raphael portray some of their important representatives in the fresco, thus giving them pride of place in his audience chamber.

this scene of worship. In the background a magnificent piece of architecture, in the style of Bramante, towers above, opening up to give a view of the sky.

Once again Raphael separated the historical figures on the left – the ones who actually attended the Mass at Bolsena – from the papal retinue on the right, a compositional principle also used in the earlier scene, *The Expulsion of Heliodorus* (ill. 94).

The third wall, on which Raphael painted *The Freeing of St. Peter* (ill. 95), is also broken up by a window, though centrally this time. Here Raphael employed a similar solution to the one he adopted in *The Mass at Bolsena*. Once again, the picture has a symmetrical, three-part architectural structure. On the left and the right, steps lead up into the scene, whilst the dungeon in the center lies just above the window opening. An angel frees St. Peter from his chains, then, holding him by the hand, leads him out of the dungeon. The choice of subject can again be explained from the biography of

Julius II, whose titular church was called San Pietro in Vincoli, St. Peter in Chains. The most important relics preserved there were the chains with which St. Peter had been bound in prison. Julius withdrew to this church to give a prayer of thanks when, in 1512, he heard of a victory over the French forces threatening the Papal State.

When Julius II died, on 21 February 1513, Raphael had probably not started work on the fresco. Nevertheless, he had already decided on the overall design, as we can see from a sketch that was probably made when the pope was still alive (ill. 96). In the drawing, the architecture and the figures are already sketched out as they will appear in the fresco; in other words even at this early stage Raphael was clear about the narrative structure of the work. In the left foreground we see a soldier who is aware of the light issuing from an angel who has appeared in St. Peter's prison cell. Two guards standing further back are

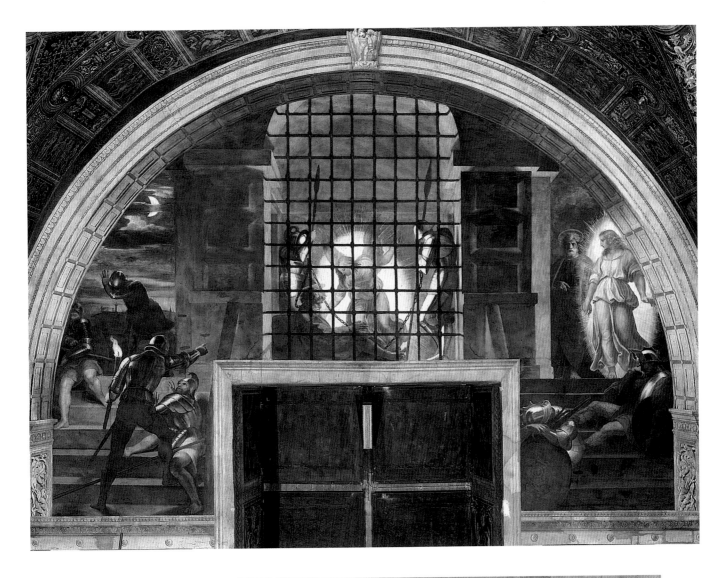

95 (above) *The Freeing of St. Peter*, 1514
Fresco, width at the base 660 cm
Vaticano, Stanza di Eliodoro, Rome

The story in the New Testament says that King Herod
took Peter prisoner and intended to have him killed. In
prison the Apostle was chained to two guards, but an
angel of the Lord freed him despite the close watch. The
fresco is dated 1514 on two painted tablets in the picture.

96 (right) Study for *The Freeing of St. Peter*, ca. 1512
Pen and ink wash, highlighted in white chalk over stylus
and charcoal underdrawing, 25.7 x 41.7 cm
Galleria degli Uffizi, Gabinetto dei Disegni e delle
Stampe, Inv. 536E, Florence

In spite of the heavy damage on the upper edge, the
drawing reveals how Raphael developed *The Freeing of
St. Peter*. At this stage he was concerned with indicating
the main areas of light and shadow in order to create the
desired light effect in the fresco.

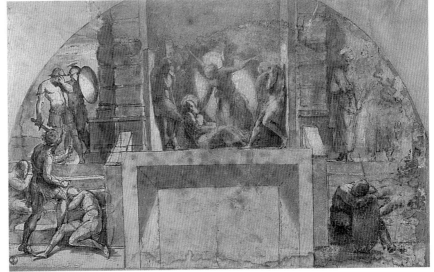

blinded by the brightness of this figure and hold their hands in front of their eyes; on the right, soldiers lie asleep.

In the fresco Raphael reduced the number of figures on the left, and instead emphasized both the monumentality of the individual figures and the expressiveness of their gestures. In comparison with the sketch, the torchlight in the painting greatly enhances the drama of the scene on the left.

In the fresco Raphael also solved a problem which had remained unresolved in the drawing. In the drawing the central room is not immediately recognizable as a prison. It was not until he completed the painting that Raphael put bars over the cell, creating one of the most remarkable examples of *contre-jour* painting in the history of art. Light appears in the picture in several different forms. Dawn is already breaking on the horizon, whilst the moon is still shining in the night sky. The torch held by the soldier on the left lights the action on the steps dramatically, and the unearthly brilliance of the angel illuminates both the prison and the right-hand side of the picture. This glowing light radiating

from the angel, which bathes him in pastel tones, places him on a different level of reality. This was the first time that Raphael used light, as well as color, to distinguish between human and heavenly figures. He continued to use this technique, which he displayed to magnificent effect in the Sistine Madonna (ill. 103).

Although Raphael's main task was to decorate the Stanze, he still found time for a subject that had preoccupied him for a long time: the Madonna and Christ Child with the boy Baptist. A drawing in Lille documents the compositional considerations that Raphael developed in three Madonna pictures. In the center of the drawing we see the sketch for the *Madonna Alba* (ill. 97), which more or less matches the painting. In the upper left-hand corner of the picture Raphael drew two other figure studies (ill. 98), preparatory sketches in which he explores the relationship between the Virgin Mary, the Christ Child, and the boy Baptist. The drawing in the center has also been linked with the *Madonna della Tenda* (ill. 99), but in this drawing Raphael appears to be toying with the idea of a circular composition, for the Madonna's back is bent in such a

97 *Madonna Alba*, 1511–1513
Panel transferred to canvas, 95 cm in diameter
National Gallery of Art, Washington

Paolo Giovio, Raphael's first biographer, commissioned this Madonna. Jesus has taken the cross from the boy Baptist, thus indicating the symbol of His Passion. The older boy is looking at him full of understanding, and visibly saddened. The Virgin has put her hand on his shoulder as if to comfort him.

98 (above left) *Madonna Studies*, ca. 1511–1513
Red chalk, pen and ink, highlighted in white chalk,
42.2 x 27.3 cm
Musée des Beaux-Arts, Cabinets des Dessins,
Inv. Pl. 456, Lille

The subject of the Madonna and Child presented
Raphael with the constant challenge of finding new
variations on the theme. Some of the studies were not
used as a basis for his paintings until years later. This
drawing in red chalk shows several variations on the same
page. In the center is the study for the *Madonna Alba*,
while the sketch above was used later for the *Madonna
della Sedia* (ill. 100).

99 (above right) *Madonna della Tenda*, ca. 1512–1514
Panel, 68 x 55 cm
Bayerische Staatsgemäldesammlungen, Alte Pinakothek,
Munich

The Virgin and Child are sitting in front of a green
curtain that has been drawn to one side. The boy Baptist
is pressing close to the two figures, and Jesus is trying to
look over his shoulder as if to see who is there. The
authenticity of the painting is no longer in question.
What remains controversial is whether it was executed
before or after the *Madonna della Sedia* (ill. 100), which is
closely related stylistically.

way that the figure might be fitted into a tondo. This
suggests that the sketch is more closely linked with the
Madonna della Sedia (ill. 100).

Sigismondo Conti must have commissioned Raphael
to complete the *Madonna di Foligno* (ill. 102) by 1511
at the latest, for by 18 February 1512 Conti, the Papal
Secretary and Prefect of the Stonemasons' Lodge of St.
Peter, was already dead. Until 1565 the panel adorned
the High Altar of the church of Santa Maria in Aracoeli,
where Conti is buried. Thereafter it was transferred to
the Franciscan church of Foligno (which explains its
present name), where it remained for over 230 years.

Here the picture type Raphael chose was again that of
the *Sacra Conversazione*. The donor is included in the
picture, and is kneeling on the right, with St. Jerome
recommending him to the Virgin Mary, who, in turn,
is interceding between the saint and Christ. The viewer
is also involved, for St. John the Baptist stands on the
left, looks straight at us, and points – in a traditional
gesture – to the Madonna. In front of him kneels St.
Francis, fervently interceding for all those who are
praying before the picture. His slightly inclined head,

his beatific expression, the firm grip he has on his
crucifix, and his relaxed gesture, made towards the
viewer, all anticipate Baroque motifs. Raphael had
mastered a pictorial language that allocate a specific role
to each figure – a role conveyed through pose, look, and
gesture – before he painted his Roman works. What is
new is the visionary concept, which presents the
Madonna and Christ Child enthroned on clouds, with
a yellow light behind them. Here, Raphael was drawing
on an old tradition: the Roman emperor Augustus is
supposed to have had a vision in which the Virgin Mary
with the Tiburtine Sibyl appeared against a burst of light
– a vision that was said to have taken place where the
church of Santa Maria in Aracoeli, the church for which
Raphael's picture was intended, was built.

Once again Raphael was faced with the problem of
having to depict various levels of reality in a single
picture. The three saints really do see the vision before
them: St. Jerome is looking directly at the Virgin Mary
and with his right hand is pointing out the meteorite
that is falling in the depths of the picture. Conti, on the
other hand, has a blank expression: he appears not to see

RAFFAELLO SANZIO
N. AD URBINO 6 APRILE 1483
M. A ROMA 6 APRILE 1520
MADONNA DELLA SEGGIOLA

151

101 (right) Raphael's Workshop
Madonna with the Fish, ca. 1513–1515
Panel, transferred to canvas, 215 x 158 cm
Museo Nacional del Prado, Madrid

The Archangel Raphael is presenting the young Tobias to the Virgin enthroned in the center. Tobias is holding a shining fish, with whose gall bladder he has, according to the story in the Old Testament, cured his father's blindness. St. Jerome is on the right with a lion (his main attribute) and a magnificent book. The work is believed to be by workshop assistants, including Francesco Penni and Guilio Romano.

100 (opposite) *Madonna della Sedia,* 1512–1514
Panel, 71 cm in diameter
Palazzo Pitti, Galleria Palatina, Florence

The bodies of the Virgin, Christ, and the boy Baptist fill the whole picture. The tender, natural looking embrace of the Mother and Child, and the harmonious grouping of the figures in the round, have made this one of Raphael's most popular Madonnas. The isolated chair leg is reminiscent of papal furniture, which has led to the assumption that Leo X himself commissioned the painting.

the vision; as far as his prayer of thanksgiving to the Virgin Mary is concerned, he is dependent on his intercessor, St. Jerome.

The *Sistine Madonna* (ill. 103) is probably Raphael's most famous Madonna. What is the source of its appeal? Behind a drawn-back curtain we see an apparition bathed in golden light, a heavenly vision. Walking on clouds, the Madonna moves towards us, the hem of her robe fluttering, her shawl blown out by the wind. An elegant rhythm characterizes the entire figure. She holds the Christ Child up to be seen, but protectively; her sad

expression indicates that she is already aware of her son's fate. He sits confidently in her arms, which makes His shyly inclined head seem all the more gentle, just as the uncertainty in his eyes makes the way He is holding His mother's shawl all the more expressive. Like the Virgin Mary, He is majestic, yet responds in a very human way to the fate that awaits Him.

The saints on the left and right form part of the vision. We can recognize St. Barbara by her attribute, a tower. The kneeling pope has been given a tiara on which there is an acorn from the della Rovere coat-of-arms. His

103 (right) *Sistine Madonna,* ca. 1513/14
Canvas, 265 x 196 cm
Staatliche Kunstsammlungen, Gemäldegalerie Alte Meister, Dresden

Generations of visitors to the Gemäldegalerie Alte Meister in Dresden have been deeply impressed by the way in which Raphael portrayed the Madonna in this painting. It has been reproduced over and over again, and almost everyone is familiar with the putti leaning on the balustrade. The Madonna appears from behind a curtain, confident and yet hesitant. The curtain gives the illusion of hiding her figure from the eyes of the onlooker and at the same time of being able to protect Raphael's painting.

102 (opposite) *Madonna di Foligno,* ca. 1511/12
Panel, 320 x 194 cm
Vaticano, Pinacoteca Apostolica Vaticana, Rome

The papal secretary Sigismondo de'Conti donated this *ex voto* altarpiece in 1511. A meteorite had fallen on Conti's house, a catastrophe Conti himself survived. Raphael portrays this event in the background. Conti is kneeling in the foreground and St. Jerome is recommending him to the Madonna, while John the Baptist and St. Francis are on the left.

features are those of Julius II; the halo, however, means this is meant to be Pope Sixtus, the patron saint of the della Rovere family. This interpretation is supported by Vasari, who states in his "Lives" of 1550 that this picture was to be found on the High Altar of the Abbey Church of St. Sixtus in Piacenza. This church owned some relics of St. Barbara, which explains why she appears in the picture together with St. Sixtus. Julius II had a personal connection with this abbey, and during his period as a cardinal he gave financial support to various building

projects there. What is not yet clear, however, is whether the picture was simply sent to Piacenza, or whether it was in fact intended for this location from the very beginning.

This is the only altarpiece Raphael painted on canvas rather than wood panel. This has led to the suggestion that it formed part of the temporary feature adorning the tomb of Julius II. According to this interpretation, the deceased Julius II appears as St. Sixtus, professing the following as he intercedes in heaven for humanity,

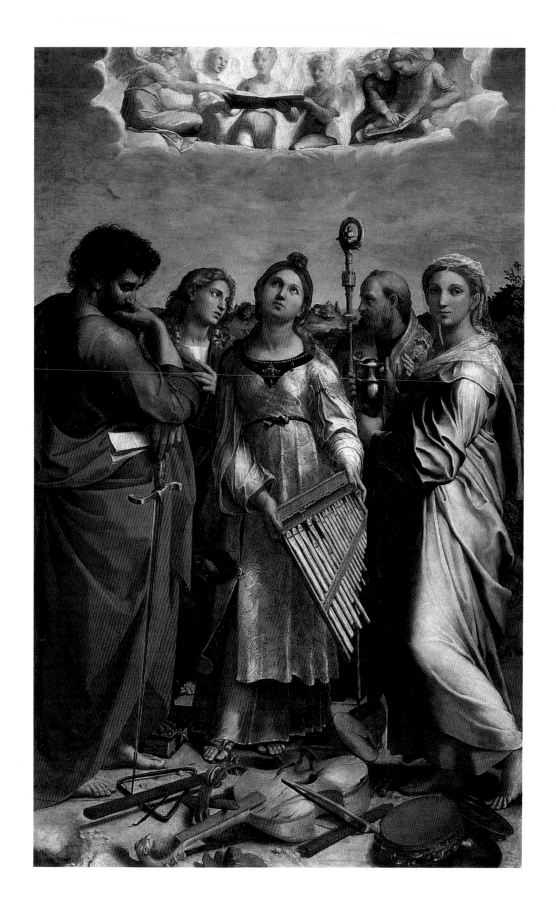

105 (above) *St. Cecilia with Saints* (detail ill. 104), ca. 1514–1516

Vasari attributed this wonderful still life to Raphael's assistant, Giovanni da Udine. A close examination has shown, however, that the instruments are by the same hand as the rest of the painting, namely by Raphael.

104 (opposite) *St. Cecilia with Saints*, ca. 1514–1516
Panel, transferred to canvas, 238 x 150 cm
Pinacoteca Nazionale, Bologna

This altarpiece was commissioned by Elena Duglioli dall'Olio of Bologna. She was famous for having visions and ecstatic fits in which music played a great part, which is probably why she asked for a picture of St. Cecilia, the patron saint of music. Raphael decided on a painting in the style of a *Sacra Conversazione*, with St. Cecilia in the center surrounded by St. Paul, St. John, St. Augustine, and Mary Magdalene.

together with the Virgin Mary: "I, Julius, am bringing my influence to bear on behalf of the world." His gesture could well be interpreted in this way.

In his *St. Cecilia with Saints* (ill. 104), which dates from around the same time as the Sistine Madonna, Raphael painted another large-scale altarpiece. Elena Duglioli dall'Olio, who was later sanctified, commissioned the painting for her family chapel in the church of San Giovanni in Monte, Bologna, which was completed in 1516, after some rebuilding work.

Her head inclined to the side and her eyes gazing upwards, the saint, who has just stopped playing her organ, is listening to the singing of an angelic choir. Raphael had used this pose in an earlier picture, *Parnassus*, when depicting blind Homer receiving divine inspiration. St. Paul, St. John the Evangelist, St. Augustine, and Mary Magdalene stand about her like pillars, with calm gestures and restrained movements – only St. Cecilia can hear the music. The

directions in which the figures are looking guide the viewer through the picture. Mary Magdalene's gaze, directly at the viewer, draws us into the picture, her arm then leading us to the pictorial center. Behind St. Cecilia, St. Augustine and St. John exchange meaningful looks and seem to be communing silently about the saint; next to her, St. Paul looks quizzically at the instruments lying on the ground (ill. 105). At first it is surprising that these are damaged and unplayable; in fact, this is a way of showing the limits of earthly music, which cannot equal divine harmonies. As the art historian Anna Maria Brizo has recognized, Raphael made the divine accessible through the figures of saints fulfilled by the vision: God's presence becomes tangible in the mystical experience of human beings. Worship itself has become the picture's subject, for only worship can lead to a vision of the divine.

MASTERY ACHIEVED: 1513–1520.
THE PONTIFICATE OF LEO X

When Julius II died in 1513 Raphael had to interrupt his work on the Stanze only briefly, for very soon Giovanni de' Medici, who took the papal name of Leo X, was elected as his successor. He was expected to inaugurate a period of peace, and there were hopes for a new unity between Church and Christendom. People understood the name Medici, meaning "doctor," as a reference to Leo's task – to heal the wounds of the Christian world. His temperament was very different from that of his warlike predecessor, and he did indeed use his diplomatic skills to make the Papal State stronger. When Leo X made his triumphant entry into Rome, the banker, Chigi, made a apt observation: warlike Mars was being followed by Pallas Athene, the goddess not only of war, but also of wisdom and the arts. Like his predecessors, Leo saw it as his duty to re-establish the glory of ancient Rome under papal leadership. He very nearly achieved this aim, though he was to go down in history as the pope under whom the Western Church finally split apart. He also left his successors a mountain of debts.

This cultivated pope found in Raphael a man who could realize ambitious cultural objectives, and he greatly extended the artist's range of tasks. First he was to complete the frescoes in the Stanza di Eliodoro. In the case of *The Freeing of St. Peter* no change seemed necessary, for by sheer coincidence the scene alluded to one of Leo's personal experiences – when he was a cardinal, the French had temporarily made him a prisoner-of-war in Ravenna.

For the fourth wall Julius II had foreseen a painting of the meeting between Leo I and Attila, King of the Huns, in 452 – by another coincidence, this was an incident in which a patron saint of the new pope was the main figure. In the Renaissance a person's name was considered very important, since it was seen as determining its owner's character and personal destiny. Like his predecessor, Leo X saw himself confronted by a Turkish threat to the West. Indeed, it is possible that Giovanni de' Medici chose the name Leo solely for the reason that, following the example of Leo I, he wanted to avert a Turkish threat. Accordingly, Raphael was able to retain the projected subject under the new pope, even though he reworked the composition in certain key respects.

In a drawing in the Louvre from the time of Julius II, the Apostles, St. Peter and St. Paul, halt Attila and his warriors in the foreground, whilst the papal retinue appears in the background. In the fresco, however, the pope is in the foreground, riding in from the left and with a view of Rome behind him. With just a gesture of his hand Leo succeeds in halting the advance of the attacking Huns. God has intervened at his request. The two Apostles, St. Peter and St. Paul, who hover above Leo armed with swords, represent the divine, but they are acting only at the instigation of the pope – a pope who has the features of his later successor, Leo X (ill. 106).

The narrative is presented more dramatically here, so new compositional solutions were called for. Raphael found them by exploring classical relief sculptures – those on Trajan's Column in Rome, for instance, whose elaborate gestural language fascinated him. He replaced his much-admired symmetrical lay-out with a balanced interplay between different masses and forces, though his compositions were still full of contrasts. Whilst the papal retinue on the left looks authoritative and is virtually static, the figures in pastel colors on the right-hand side of the picture are violently agitated.

In mid 1514 Raphael began decorating another room, now known as the Stanza dell'Incendio. The plan was to show four different scenes, in each of which a pope called Leo took part. They are: *The Burning of the Borgo* (ill. 107), *The Battle of Ostia* (ill. 108), *The Coronation of Charlemagne* (ill. 110), and *The Justification of Leo III*. For *The Burning of the Borgo* Raphael used the basic idea of the Attila scene. Once again it was the pope who, with merely a movement of his hand, called a halt to the blazing inferno that threatened to destroy a whole district of the city.

The start of the work on this project coincided with the death of Bramante, who had, up to then, supervised the rebuilding of St. Peter's. To fill the vacant post, Leo X organized a competition. Much to his own surprise, as he explains in a letter, Raphael won and Leo X appointed him the new architectural supervisor of the rebuilding work on St. Peter's.

He also appointed two experienced collaborators – Fra Giocondo from Verona, and Giuliano da Sangallo

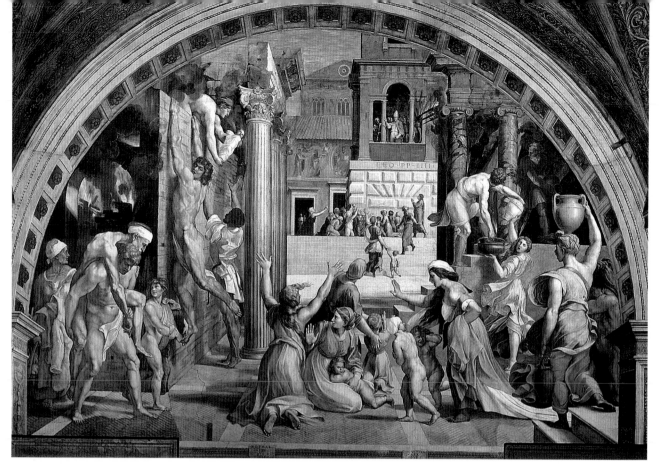

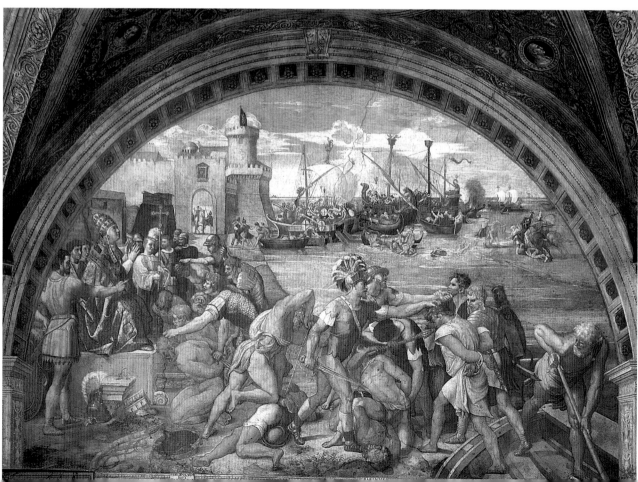

107 (opposite, above) *The Burning of the Borgo,* 1514
Fresco, width at base 670 cm
Vaticano, Stanza dell'Incendio, Rome

The event depicted happened in AD 847 and is
documented in the "Liber Pontificalis" (a collection of
early papal biographies). Pope Leo IV managed
miraculously to halt the raging fire, which was
threatening an area of the city, by his benediction from
the loggia of Old St. Peter's. While those in the
foreground are desperately trying to put out the fire, the
female figure in yellow with her back to us is begging
them to look at the only effective source of help, the
pope.

108 (opposite, below) *The Battle of Ostia,* 1514/15
Fresco, width at the base 770 cm
Vaticano, Stanza dell'Incendio, Rome

In AD 849 the Arab fleet attacked the papal forces, but
was destroyed by a storm. On the left, Leo IV, in the
figure of Leo X, can be seen giving thanks. The scene is
probably a reference to Leo's intentions to mount a
crusade against the Turks. The fresco is the work of
workshop assistants.

109 (right) *Nude Study,* ca. 1515
Red chalk over metal stylus, 41 x 28.1 cm
Graphische Sammlung, Albertina, Inv. 17 575, Vienna

This is a nude study of live models, but only the figure in
the foreground was used, for a field-captain in *The Battle
of Ostia* (ill. 108). Raphael gave the page of drawings to
Albrecht Dürer, and the title is probably in Dürer's
handwriting, with Raphael's name and the date, 1515.
Raphael in turn received a self-portrait by Dürer, which
has since been lost.

110 *The Coronation of Charlemagne*,
ca. 1516/17
Fresco, width at the base 670 cm
Vaticano, Stanza dell'Incendio, Rome

Charlemagne was crowned by Leo III in AD 800 in the
Vatican Basilica. In the fresco the Emperor has the
features of the French king, Francis I, who had been on
the throne since 1515. The reason for this is that Leo X,
unlike his predecessor, was seeking a political alliance
with the French, and this was a way of honoring Francis I.

the Elder, the Medici's architect – to help Raphael, who
had no architectural experience. Within a very short
time, they had helped him to develop his own expert
knowledge. They made him familiar with the classical
textbook on architecture by Vitruvius, and in 1514
Raphael commissioned the scholar Fabio Calvo to
translate this into Italian, a translation he then studied
intensively. This manuscript, complete with Raphael's
handwritten comments, is now in the Staatsbibliothek,
Munich. Following the death of Fra Giocondo in 1515
and of Sangallo in 1516, Raphael was appointed to be
in sole charge of the colossal project.

Raphael's new duties had two decisive effects on
his work. First, he had scarcely any time left for
individual works of his own, so that his workshop
became increasingly involved in completing projects
(ills. 111–113), as had happened already with the

frescoes in the Stanza dell'Incendio. The second effect
was to deepen Raphael's interest in the ancient world.
In August 1515 Leo X appointed him Director of
Antiquities, his role being to take care of Rome's
ancient monuments. This post required a wide-ranging
knowledge of classical architecture, sculpture, and
painting. It also reaped artistic rewards for Raphael in
his future work on room decoration. He had a map
prepared on which all the city's ancient buildings were
to be marked. By the time of his death only a small
fraction of this map had been completed, and even that
has not survived.

The Sistine Chapel was the official private chapel of
the popes, where the Conclave, the body which elected
a new pope, also met. The rebuilding of St. Peter's made
it necessary for other high-level ceremonies to be held
in the Chapel. Pope Sixtus IV della Rovere, the uncle of

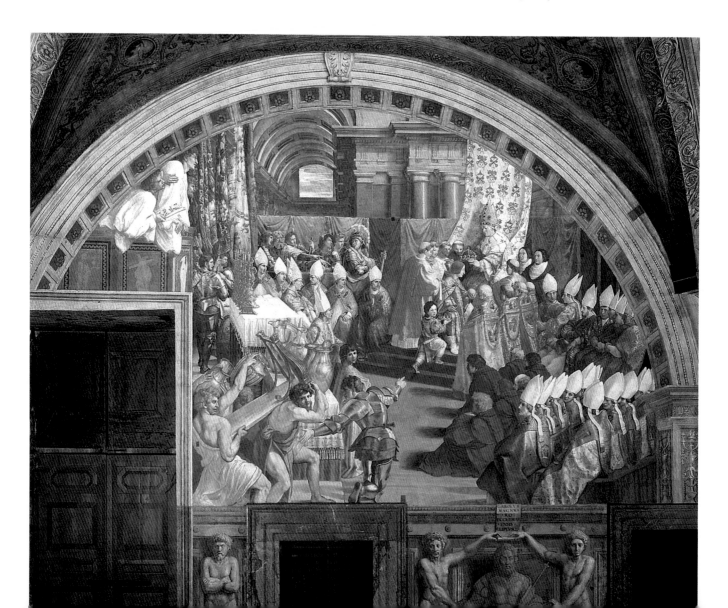

111 (right) *The Boy Baptist in the Desert,* ca. 1517
Canvas, 163 x 147 cm
Galleria degli Uffizi, Florence

This painting was carried out to Raphael's design by workshop assistants. The brown rocky background and the modelling of the figures show the strong influence of Leonardo. The quality of the light is not typical of Leonardo, though; it does not surround the figures softly but models them sharply.

112 (below left) *The Hill of Calvary,* ca. 1515
Canvas, 318 x 229 cm
Museo Nacional del Prado, Madrid

The religious community the Olivetani of Santa Maria dello Spasimo in Palermo commissioned this picture from Raphael. When it was being transported by sea to Sicily, it is supposed to have gone down with the ship, and to have drifted into the port of Genoa. Monks found it there and thought its appearance a miracle.

113 (below right) *St. Michael and Satan,* 1518
Panel, transferred to canvas, 268 x 160 cm
Musée du Louvre, Paris

The painting was a gift from the pope to the French king, Francis I. It is now debated whether the work, long thought to be by workshop assistants, may not in fact be by Raphael after all, the stylistic anomalies being attributable to poor restoration techniques.

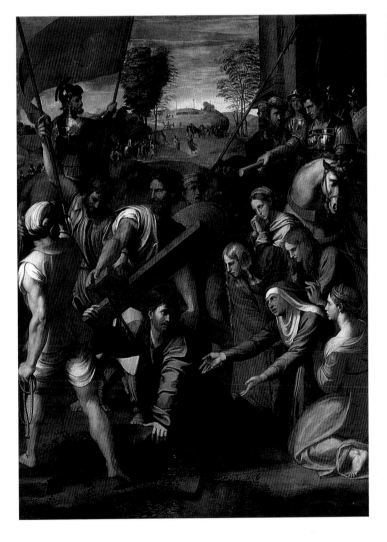

114 Raphael's Workshop
Vision of the Cross (detail ill. 83), view of Rome,
1520–1524

This view of the "Tomb-pyramid of Romulus", which is no longer there, and the so-called Citadel of Sant'Angelo together with the bridge of Sant'Angelo, is an example of Raphael's interest in ancient Rome. The view Raphael has chosen more less matches the view he had of Rome in 1520 from his Vatican loggie, which are located right behind the wall painted with the fresco. The Citadel of Sant'Angelo appears to be Raphael's reconstruction of the original ancient building, the erstwhile Hadrian Mausoleum, as it might have looked in the days of Emperor Constantine. By depicting this view of ancient Rome, Raphael is suggesting to anyone viewing the fresco that Constantine experienced his vision in the precise place where the Vatican State is now located. By this means Raphael was able to confirm in a very subtle manner, that the Popes had established themselves in Rome – more specifically – in the Vatican.

With his plan to rebuild St. Peter's, Pope Julius II hoped to substantiate his claims that Rome should take a leading position in the world once again. Ancient structures played a key role, for they were the most important sources of stone for new buildings. Humanist culture, however, with its keen interest in the ancient world, made it clear that breaking up ancient monuments was a form of vandalism. It therefore comes as no surprise that a post of Director of Antiquities (*Commissario dell'Antichità*) was created, and that under Pope Leo X Raphael was entrusted with this office. One of his duties was to evaluate ancient stones, and to withdraw them from the building projects if they bore inscriptions that needed preserving. This helped to prevent indiscriminate over-exploitation, though the economic situation of the popes did not make it possible to put an end to the practice of re-using stone from ancient monuments.

This is the background to a letter drafted by Raphael and Baldassare Castiglione known as the "Letter Concerning the Preservation of Ancient Monuments." It provides a report on the current situation of ancient monuments in Rome, and calls for all ancient structures be surveyed and listed. Astonishingly, the suggestions about how to proceed correspond closely to modern archaeological practice. The buildings were to be accurately surveyed and drawings made of their ground plan, elevation, and cross-section. For the reconstruction, all available written sources – such as ancient and medieval descriptions of the city – were to be consulted. The aim was to create a basis for the replanning of the whole city, and to relearn long-forgotten building techniques, so that a new and dignified Rome could rise up amid the ruins of the old. Posterity can only regret that Raphael's plan to map the city in this way remained nothing more than a proposal.

Julius II, had had the Sistine Chapel built, and had commissioned the leading artists in Florence in the late 15th century to adorn it with episodes from the lives of Christ and Moses. He also had imitation tapestries showing the della Rovere coat-of-arms painted.

On important Church feast days venerable wall-hangings were hung in front of these simulated tapestries. The hangings depicted scenes of Christ's Passion, and, according to one legend, they came originally from Jerusalem. In Leo X's opinion these had become too worn and unsightly and had therefore to be replaced. The timing was clearly excellent, for this replacement gave Leo an opportunity to leave behind a visible sign of his own papacy in the most important chapel in Christendom. The coat-of-arms of Leo X, commissioned from Raphael, unmistakably adorns the borders of the new tapestries.

Initially a scholar (no name has come down to us) was presumably commissioned to provide a program for the cycle of tapestries, and instructed to select the scenes that would accord with the key features of the new pope's ecclesiastical policy while remaining in keeping with the decoration already there. Leo expected Raphael to interpret these themes artistically. Presumably, Raphael was commissioned to do this in late 1514 or early 1515; by June 1515 he had received an advance payment. The designs were completed by late 1516, since we have documentary evidence that the final payment was made on 20 December.

The tapestries were woven in the finest tapestry workshop of the day, that of Pieter van Aelst in Brussels. One tapestry was completed by 1517, and seven tapestries were ready to be hung in the Sistine Chapel for the Christmas festivities of 1519. Three others must have arrived shortly before Leo's death in 1521, for the inventory made just after his death lists a total of ten tapestries. During the Sack of Rome in 1527, these works were stolen, and were not returned until the 1550s. Seven of the cartoons – designs drawn to scale – are in the Victoria and Albert Museum, London. The tapestries themselves, all woven by Pieter van Aelst, are now in the Vatican Museums.

The tapestries recount stories from the Acts of the Apostles. Four scenes depict scenes from the life of St. Peter. These are *The Handing-over of the Keys*; *The Miraculous Draught of Fishes* (ill. 116); *The Healing of the Lame Man*; and *The Death of Ananias*. The other six tapestries illustrate scenes from the life of St. Paul. They are: *The Stoning of St. Stephen*, which depicts an event St. Paul ordered; *The Conversion of St. Paul*; *The Blinding of the Sorcerer, Elymas*; *The Sacrifices in Lystra*; *St. Paul in Prison*; and *St. Paul Preaching in Athens* (ill. 117).

St. Peter and St. Paul were both martyred in Rome, a fact that substantiated and legitimated the choice of this city as the seat of the papacy. Leo X was using the program of the tapestries to demonstrate this, and thus to assert that ecclesiastically his immediate predecessors

115 (below left) Cartoon for *The Miraculous Draught of Fishes*, ca. 1514/15
Mixed media on paper, mounted on canvas, 360 x 400 cm
Victoria and Albert Museum, London

A scientific examination using infra-red light has proved this cartoon to be by Raphael himself. Detailed underdrawings were found beneath the layer of paint, which are recognizably by Raphael's sure hand. The drop of paint running vertically down the cartoon shows that it was hung up for painting.

116 (below right) *The Miraculous Draught of Fishes*, ca. 1517–1519
Tapestry, 512 x 492 cm
Vaticano, Pinacoteca Apostolica Vaticana, Rome

By a miracle, one of the boats is suddenly full of fish, and the sailors in the other are pulling a full net out of the water. Jesus is sitting in the boat with Peter, asking him to give up being a fisherman and become a disciple. The border portrays the entry into Rome of Giovanni de' Medici in 1513, and the homage to Pope Leo X.

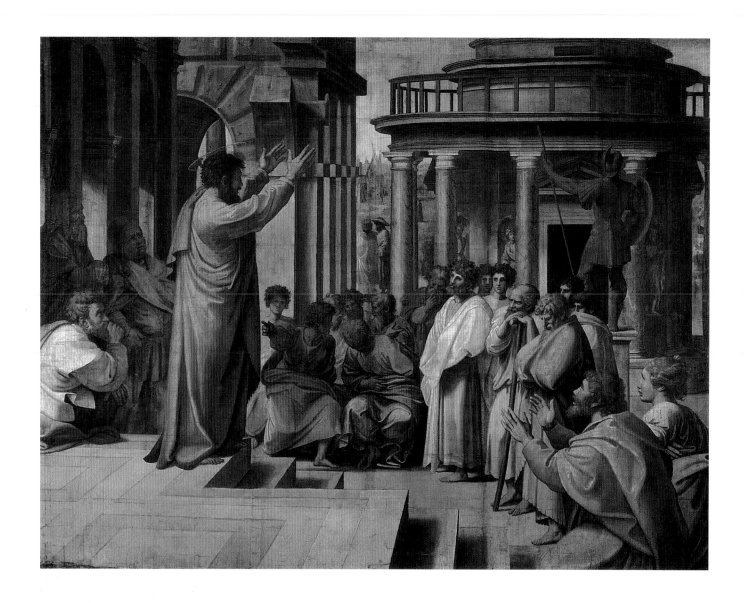

117 Cartoon for *St. Paul Preaching in Athens,* ca. 1514/15
Mixed media on paper, mounted on canvas, 343 x 442 cm
Victoria and Albert Museum, London

The Acts of the Apostles say that Paul was enraged when
he saw how many images of pagan gods there were in
Athens. A group of philosophers asked him to explain his
position in the Areopagus, the ancient court site in
Athens. In the cartoon Paul is lending emphasis to his talk
with dramatic gestures, while those listening are all
reacting in very different ways. The man on the right at
the front, with the ecstatic look on his face, is probably
Dionysius Areopagita, who is said to have been converted
to the Christian faith by this sermon.

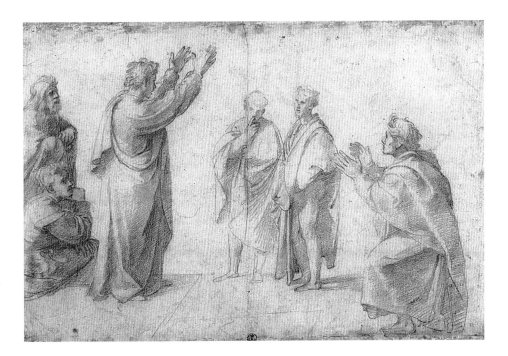

118 Study for *St. Paul Preaching in Athens,* ca. 1514/15
Red chalk over stylus underdrawing, 27.8 x 41.8 cm
Galleria degli Uffizi, Gabinetto dei Disegni e delle
Stampe, Inv. 540E, Florence

Raphael made drawings for his tapestry cartoons, just as
he did for his paintings. The figure of St. Paul was
adopted into the final version almost unchanged, but the
positions of the figures to right and left in the cartoon
were changed markedly. The man in the center with his
finger laid reflectively on his lips was abandoned entirely.
It is possible that live models from Raphael's workshop
posed for this drawing.

had been right to return to Rome after the so-called
Babylonian Captivity in Avignon.

Raphael's designs revolutionized the tradition of
tapestry weaving, for they required a faithful rendering
of atmosphere, light, textures, and pictorial form that
had never been seen in this medium before. Here, for the
first time, the usual monochrome background, or one
depicting flowers and small ornaments, was abandoned
in favor of a genuine pictorial space, in which the figures
could move about.

The scene *The Miraculous Draught of Fishes* (ills. 115,
116) is unique not merely for thus changing the
iconography of tapestry weaving. Dawn is breaking
over the lake, birds fly out from the depths of the picture
and pass over the fishermen. These are powerfully built
men dressed in simple shirts or tunics, and we can see
their reflections in the water. An atmospheric light
fills the whole composition. The arm of one of the
fisherman extends into the depths of the picture and is
shown *contre-jour*, one side catching the red glow of the
dawn. Glowing highlights accentuate the garments and
model the muscular bodies. These painterly effects
presented a great challenge to the tapestry weavers. In
particular, the shirt of the Disciple who is so amazed by
the miracle that he has jumped up in the boat in utter
bewilderment tested the skills and resources of the
Brussels weavers to their limits. Here, Raphael painted
highlights shading into yellow together with bluish-gray
shadows on a green half-tint shot through with orange
(ill. 115).

In the task he had set himself Raphael was facing a

double challenge. First, he was well aware how
important this project was to Leo X. Secondly, he felt
overshadowed by Michelangelo's Sistine ceiling, by
which he knew he would be measured as an artist.
Michelangelo had achieved impressive and in some cases
extreme color effects.

Raphael remembered his own pictorial effects, as
demonstrated in the frescoes of the Stanza di Eliodoro.
In his designs he staked everything on the atmospheric
effects of the light and color, enlivened by contrasts and
delicate nuances. In this respect, however, the final
outcome was a failure, in that he had over-estimated the
technical potential of tapestry weaving. All the same, the
tapestries were an enormous success when shown in the
Sistine Chapel in 1519.

At the same time Raphael again succeeded brilliantly
in his historical depictions. As earlier in *The School of
Athens*, he developed a pictorial language which made
the ancient world alive and tangible. The compositions
are full of tension and the narrative style dramatic.
The figures' facial expressions can be easily read, their
grand gestures are eloquent, and they elicit varied and
unmistakable reactions from the onlookers (ill. 117).
In *St. Paul Preaching in Athens* (ill. 118), the viewers
become the listeners, joining the circle of those people
the Apostle is addressing. In this scene Raphael
succeeded in creating a classical mood by integrating
into the composition motifs from Roman reliefs and
classical figures, buildings, and statues.

By the time his work in the Stanza di Eliodoro was
almost finished Raphael had achieved total mastery of

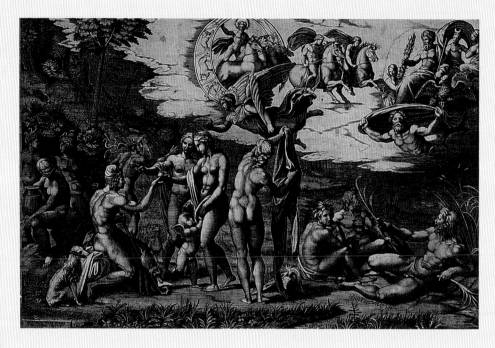

119 Marcantonio Raimondi (after Raphael)
The Judgement of Paris, ca. 1514–1518
Engraving, 29.8 x 44.2 cm
British Museum, London

Marcantonio Raimondi contributed greatly to Raphael's
fame by engraving many of his paintings. A drawing
mentioned by Vasari, and now lost, was the basis for the
engraving. It shows Paris, King Priam's son, giving the
prize of the golden apple to Aphrodite as the most
beautiful goddess.

Vasari described Raphael as a magnanimous prince among
painters, who gave work to a great number of pupils and
"instructed them with a degree of love which is normally
due to sons, not artists." We do not know for certain how
true this image of a virtuous artist is in Raphael's case. What
is beyond doubt, however, is that Raphael was head of a
well-organized workshop which employed numerous
collaborators. The most important among them were Giulio
Romano and Francesco Penni, who after Raphael's death
inherited his workshop.

Raphael carefully checked the quality of the works
produced and guaranteed them with his name. Because of
the sheer volume of paintings commissioned, as well as his
time-consuming work as architect and conservator, he was
unable to complete all the works himself. Vasari criticized
this practice, especially in the case of his later works.
Raphael did, however, employ carefully chosen specialists.
Giovanni da Udine, for example, recommended by
Baldassare Castiglione, painted the superb fruit and flower
garlands in the Farnesina. Raphael also employed highly
qualified collaborators to complete commissioned panels
and frescoes from his preparatory studies. This was the case
even when the commission came from so demanding a
patron as Pope Leo X: the *The Holy Family* (ill. 120) which
Leo gave to Claude, the wife of the French king, Francis I,
certainly bore Raphael's name, though it is now generally
agreed that the painting was by his workshop, and largely
the work of Giulio Romano. The preparatory drawings
for this picture have survived and are preserved in the
Louvre and the Uffizi, and they confirm that Raphael
himself prepared the painting's composition. Such a division
of labor was quite common in artists' workshops long
before Raphael's time. Nevertheless, no one had previously
delegated on this scale, particularly on projects as complex
as the decoration of the loggias in the Vatican.

Raphael's entrepreneurial spirit is also well illustrated by
his response to engraving. According to Vasari, Raphael was
motivated by Dürer's engravings to "show what he could
achieve in this form of art." However, the possibility of
becoming known to a much wider circle through the
medium of printed reproductions was probably as important
to him as the challenge of a new technique. In order to satisfy
the demand for prints, one of the assistants in Raphael's
workshop ("il Baviera," the Bavarian) was responsible for
printing engravings. In Raphael's later, highly productive
collaboration with the engraver Marcantonio Raimondi the
inscription "Raphael invenit" on an engraving like *The
Judgement of Paris* (ill. 119) made it clear that Raphael had
originated the composition and that any credit for the
invention, the *inventio*, of the work went to him. The
technique of graphic reproduction made it possible for
Raphael to make his works known north of the Alps as well,
and it played an important part in establishing his
international reputation. A striking example of the spread of
his influence is the quotation by the Netherlandish artist
Bernard van Orley – on the right wing-panel of his *Job
Altarpiece* (ill. 121) – of the river-god from Raphael's *The
Judgement of Paris*, which Raimondi had published as a print.

120 *The Holy Family*, 1518
Panel transferred to canvas, 207 x 140 cm
Musée du Louvre, Paris

Leo X commissioned this *Holy Family* with Elizabeth, the
boy Baptist and two angels, and gave it to Claude, the
wife of the French king, Francis I. Although it is signed
RAPHAEL URBINAS, the picture is not autograph
(entirely by the artist's hand). Raphael delegated the work
mainly to workshop assistants, so the signature
corresponds to a modern trademark.

121 Bernard van Orley
The Rich Man in Hell (right wing of the *Job Altarpiece*), 1521
Panel, 174 x 80 cm
Musées Royaux des Beaux-Arts, Brussels

The important Brussels artist Bernard van Orley was one of those
Italian-influenced Flemish artists who showed themselves receptive
to Raphael's work. On this wing of the altarpiece he shows the
monumental nude figure of the biblical rich man who, having
turned away Lazarus, the "poor man at the gate," is now tormented
in Hell.

122 *Portrait of Baldassare Castiglione,* ca. 1514–1516
Canvas, mounted on panel, 82 x 67 cm
Musée du Louvre, Paris

Baldassare Castiglione, a humanist and a writer, was one
of the most important men of the Italian Renaissance. His
popular book "The Courtier" gives insights into the
thinking and culture at the court of Urbino at the turn of
the 16th century, and is written in a style that is
delightfully clear and precise. Rubens admired Raphael's
portrait of Castiglione so much that he copied it.

the use of light and color. We can also see this in his
Portrait of Baldassare Castiglione (ill. 122) and in his
work *La Donna Velata* (ill. 123), which he painted
about 1516. By this time harsh color contrasts have
disappeared from the pictures. Light plays on the fabrics
and enlivens the compositions.

In the portrait of Castiglione the coloration seems
to be reduced to one main color effect, the limpid blue
of the sitter. In the woman's portrait, however, the
interest lies in the contrast between her restrained
appearance and the billowing material of her dress.
Unusually free brushstrokes here achieve the most
delicate effects, creating highlights and making the

material's texture more tangible. Raphael crops the
hands of both subjects, which has the effect of bringing
the sitters closer to the viewer. The faces of the two sitters
look at the viewer from eye-level and with an air of being
an equal.

Raphael must have completed Castiglione's portrait
before the end of 1516, for around that time
Castiglione, who was ambassador of the court of
Urbino, was recalled to Mantua from Rome, and, now
married with a child, he was not able to return to his
ambassadorial duties in Rome before 1519. His portrait
stayed with his family, as a letter from the writer, Pietro
Bembo, dated 19 April 1516, makes clear. It is also

123 *La Donna Velata,* ca. 1514–1516
Canvas, 82 x 60.5 cm
Palazzo Pitti, Galleria Palatina, Florence

The features of this woman, who has never been decisively identified, can be seen in the *Sistine Madonna* (ill. 103); the unknown woman seems to represent Raphael's ideal of beauty at this time, a fact that helps to date the painting. The style is reminiscent of that of Raphael's portrait of Castiglione (ill.122), particularly in its reduced range of colors, and this too supports the dating.

confirmed by Castiglione himself, who wrote an elegy that expresses the feelings of his wife, who stayed at home: "Only your portrait, painted by Raphael, can almost alleviate my sorrow when it makes your features present for me." The notion of attributing enough power to a painted portrait to make the subject seem present is an expression of artistic praise that goes back to classical times.

Another portrait type can be traced back to a literary tradition of classical times: that of the double portrait that commemorates the sitters' friendship. Mantegna was the first artist to paint this kind of double portrait, in 1480. A portrait of this kind by Mantegna, now lost, portrayed two writers who were separated because one of them had to go back to Hungary from Mantua. A similar situation led to Raphael's *Double Portrait of Andrea Navagero and Agostino Beazzano* (ill. 124). In this case three friends were involved, for Pietro Bembo probably commissioned the picture from Raphael. A letter which mentions a joint excursion the friends made – together with Castiglione and Raphael – to Tivoli in the Spring of 1516, talks about the circle these men had established. Moreover, because we are aware that Navagero was recalled to Venice in late 1516, we know why this double portrait was commissioned. We also know who owned it: in 1530 the portrait was hanging

124 *Double Portrait of Andrea Navagero and Agostino Beazzano*, ca. 1516
Canvas, 76 x 107 cm
Galleria Doria Pamphilj, Rome

These two humanist writers were friends of Raphael in Rome. They had, like him, come from elsewhere. Navagero came from Venice and just before he returned to Venice from Rome the two poets had themselves commemorated in this portrait.

in Bembo's house in Padua. Navagero and Beazzano seem to have just been interrupted in mid-conversation, and they are turning spontaneously towards the viewer. The magnificent lighting makes the heads look very three-dimensional, and the way they are looking from moistly glistening eyes endows both expressions with great immediacy. The rich but restrained coloration and the subtle highlights on the subjects' skin and garments relate the picture stylistically to the portraits of Castiglione and the Donna Velata (ills. 122, 123), painted shortly before.

Raphael's later portraits are painted on canvas, possibly because this is easier to transport than heavy wood panels. Also on canvas is a double portrait showing the artist himself standing behind a man on whose shoulder his hand rests familiarly (ill. 125). Raphael

painted it only a short while after the double portrait of Navagero and Beazzano, and it is stylistically related to it. Further, the expressiveness of this gesture links it to the designs for the tapestries and to Raphael's last altarpiece, *The Transfiguration* (ill. 140), works in which Raphael had developed a powerful and eloquent language of gesture. The unknown man is pointing out of the picture, but at the same time has turned towards Raphael and is looking at him. Exactly what he is pointing at is just as keenly debated as his identity. Was this unknown man one of Raphael's friends, and was the gesture of turning intended for the person commissioning the picture? If so, we should interpret this double portrait as a souvenir picture. It is also possible, however, that Raphael and the unknown man are standing in front of a mirror.

125 *Double Portrait*, ca. 1517–1519
Canvas, 99 x 83 cm
Musée du Louvre, Paris

This portrait of Raphael was not one of the artist at work
but a self-portrait with a friend. He stands calmly behind
the unknown man, looking out of the picture with a
serious expression. The friend's gesture is not meant for
the onlooker, but seems more directed at Raphael, as if he
were showing him something – himself, perhaps, in a
mirror.

Raphael also painted a very personal portrait in the
so-called *La Fornarina* (ill. 126). Turning to her left, a
half-naked woman is sitting against a background of
dense foliage in the pose of the classical *Venus pudica*. As
in that figure type, she is holding one hand modestly
over her breast, while the other is lying on her lap. In
fact, of course, these gestures only make the viewer more
aware of the beautiful subject's charms. At the same time
the index finger of her right hand points unobtrusively
– yet unmistakably – to a bangle on her upper arm,
bearing the inscription: RAPHAEL URBINAS.

Unlike the double portraits, this picture has been
painted in delicate glazes on wood. Radiographic
examination has revealed that the background was
initially laid out as a landscape view. The inscription on
the arm-bangle was also changed from its original form,

RAPHAEL URBS. Today, there is some doubt about
the authenticity of this painting on stylistic grounds.
Nevertheless, the transparent veil with a few powerfully
touched-in highlights, the delicate gradation of the soft
skin, and the superbly painted turban-like head-dress
are all worthy of Raphael. He may well have completed
the painting around 1515.

What is doubtful is whether Raphael would have
signed the work so conspicuously if it had been intended
for him or his lover. His other friendship portraits are
not signed, and in his late works signatures generally
appear only if the pictures had left Rome or if his studio
had been involved in a painting's execution. But in that
case, it is not at all clear for which collector the portrait
was intended.

Raphael also immortalized his patron, Leo X, in an

126 (left) *La Fornarina*, ca. 1518/19
Panel, 85 x 60 cm
Galleria Nazionale d'Arte Antica, Rome

Raphael signed the portrait on the bracelet and, because it is positioned so suggestively next to her naked breast, she has been identified as Margherita, the woman with whom Raphael is supposed to have been passionately in love.

127 (opposite) *Portrait of Leo X with Cardinals Giulio de' Medici and Luigi de' Rossi*, 1513–1519
Panel, 155.2 x 118.9 cm
Palazzo Pitti, Galleria Palatina, Florence

Here Pope Leo X had himself painted as a lover of the arts, with a splendidly illuminated Bible open on the table before him. His relatives, the Cardinals Guilio de' Medici and Luigi de' Rossi, surround Leo X in the picture, making a family portrait that was sent from Rome to Florence on 1 September. As the indisputable sign of the power of the house of Medici, it was hung on the occasion of Lorenzo de' Medici's wedding to Madeleine de la Tour d' Auvergne.

imposing portrait. It depicts him together with his nephews, Cardinal Giulio de'Medici, the future Pope Clement VII, and Cardinal Luigi de' Rossi (ill. 127). Initially, Raphael was planning to paint a portrait of the pope on his own. The artist must have extended the composition after 1517, for only then was de' Rossi made a Cardinal. By 1 September 1518 the painting was already on its way from Rome to Florence. In its first phase the composition was strongly reminiscent of his *Portrait of Pope Julius II* (ill. 86). Whilst Pope Julius is seated, the onlooker is standing on one side, a silent and deferential observer. In his portrait of Julius II, Raphael had concentrated primarily on depicting the pope's character; in this portrait of Leo X he placed an antique column behind the pope and showed him reading a priceless 14th-century illuminated manuscript. The

128 (left) The *Stuffetta* of Cardinal Bibbiena, 1516
2.52 x 2.52 m in outline
Vaticano, Palazzi Vaticani, Rome

Raphael's workshop decorated the Cardinal's bathroom
(*stuffetta*) with frescoes and stucco using the ancient
Roman palace of Nero, the Domus Aurea, as a model.
The ceiling and lunettes are decorated with grotesques; on
the walls there are mythological scenes, such as the birth
of Venus, in painted frames. The dado is filled with
tumbling cupids, snails, dolphins, dragons, and
butterflies.

Church dignitary looks up pensively, obviously struck
by the beauty of the book, which he has been examining
with a magnifying-glass. Raphael did not reproduce the
manuscript in exact detail, but with sufficient precision
for it to be identified as a typical Neapolitan Bible, of
which one example, the Hamilton Bible, is in Berlin.
Beside the book stands an elaborately worked golden
bell, ready to summon Leo's servants. Here Raphael has
portrayed a lover of the arts, not a potentate.

Raphael devoted all his skill to making this portrait
have an immediate impact. To help achieve this it
was vital that the pope was depicted at a precisely
determined moment. He has just been examining
the miniatures in the manuscript. Now, deep in
thought, he is staring straight ahead. The pope
dominates the picture monumentally, relegating the two
cardinals to subordinate roles. To the right of Leo X –
that is, on the privileged side – stands his nephew,
Giulio, who is turning towards the pope and, like him,
is ignoring the viewer. Cardinal Rossi, however, who is
demonstrating his closeness to the pope by holding
his chair firmly, is looking directly at the viewer. The
index-finger of his left hand is unobtrusively pointing
to the main figure, as if he wished to point out the pope

129 (above) *Portrait of Cardinal Bernardo Dovizi
Bibbiena,* ca. 1514–1516
Canvas, 85 x 66.3 cm
Palazzo Pitti, Galleria Palatina, Florence

Cardinal Bernardo Dovizi Bibbiena, the private secretary
of Leo X, was the most powerful man at the papal court.
He was, in addition, a cultured writer and humanist. He
even wrote a comedy, "La Calandria." His trust in
Raphael is demonstrated by many important
commissions. His niece even became engaged to Raphael,
but she died before the wedding and Raphael remained
unmarried.

130 Raphael's Workshop
The *Loggetta* of Cardinal Bibbiena, ca. 1516/17
15.74 x 3.12 m in outline
Vaticano, Palazzi Vaticani, Rome

Raphael decorated Bibbiena's loggetta in the style of
newly-discovered ancient Roman ornamental forms – the
walls and ceilings are adorned with grotesques, open areas
and geometric ornaments. The artist has depicted
mythological scenes in the lunettes, as well as allegories of
the four seasons in the recesses. Raphael himself was
probably responsible for the overall design and for some
of the figure studies. That said, the final decorative work
would have been undertaken by his studio associates,
Francesco Penni, Giulio Romano and Giovanni da Udine.

132 (above) *The Judgement of Solomon*, ca. 1518/19
Fresco
Vaticano, Loggia on the Second Floor, Rome

In the arch of the eleventh bay of the loggia there are four
frescoes illustrating the story of Solomon. One of
Raphael's workshop assistants designed and carried out
the work, but it is not known which one. Raphael's own
work on this theme in the Stanza della Segnatura (ill. 55)
is convincing because he confined himself to six beautiful
single figures who play their role in the story with
powerful expression. The scene in the loggia version, on
the other hand, is developed within the space.

131 (opposite) Loggia of Pope Leo X, ca. 1514–1519
65 x 4 m
Vaticano, Palazzi Vaticani, Rome

The loggias in the Vatican are one of Raphael's few
architectural projects that have been preserved. Julius II
had commissioned them from Bramante in about 1512.
After Bramante's death in 1514, Raphael completed the
loggia on the first floor. He alone was responsible for the
decorations on the second floor. This loggia became
famous for the grandiose cycle of frescoes illustrating
scenes from the Old Testament, the "Raphael Bible,"
which the workshop carried out between 1518 and 1519.

to us, though with fitting reticence. With mini-
mal means Raphael has succeeded in clarifying the
hierarchical relationships of all three people depicted,
and at the same time in involving the viewer in his
scenario.

In the early 16th century the discovery of the buried
ruins of the Domus Aurea, a building which dated back
to Nero's time, helped stimulate interest in classical
decoration. On Raphael's behalf, Giovanni da Udine
studied the wall-decorations and their production
methods. The subterranean building was colloquially
known as the "grotto." As a result, during the 16th
century this kind of decoration, which rapidly became
popular, was called "grotesque." Raphael and his studio
emulated this decorative style for the first time when
Cardinal Dovizi Bibbiena (ill. 129) gave Raphael a
commission for the decoration of his bathroom (ill. 128)
and his Loggetta (ill. 130) in the Vatican Palace. We
know from a letter that this work was completed on 20
June 1516.

At the same time, between 1514 and 1519, Raphael

was at work on another large-scale project in the Vatican
Palace, the completion and decoration of the loggias
(ill. 131). At his death, Bramante left this architecture
unfinished, so that first Raphael needed to complete the
building, before he could start on the decoration work.
For the loggia on the second floor, which had not yet
been built, Raphael moved away from Bramante's
formal architectural language and based himself instead
on the style of a classical gallery, inspired by the so-called
Tabularium, an ancient Roman building overlooking
Forum Romanum from the Capitoline Hill. The
gallery's unrestricted view over the city – a prospect the
loggia also enjoyed until the late 16th century – was
especially captivating. Under Pope Sixtus V, extensions
to the Papal Residence obscured this view.

To decorate the thirteen arcaded vaults of the loggia
on the second floor, Raphael designed the figurative
compositions (ill. 132) which where then completed by
his workshop. The subjects were scenes from the Old
Testament, though he had the columns and wall-
surfaces adorned with grotesques – in other words he

used the decorative forms, in an imitation-classical style, with which he had previously decorated Bibbiena's rooms.

Between 1511 and 1519 Raphael was also kept busy by a series of commissions from the banker Agostino Chigi (ill. 133). Chigi wanted the chapel in the church of Santa Maria del Popolo in Rome converted into a family mausoleum. Raphael designed the architecture as well as the decoration. On a square ground plan, four columns, based on Bramante's designs for St. Peter's, were to support a cupola (ill. 134) lit by windows, which was meant to be reminiscent of the Pantheon. The whole project made great play with complex perspective and precious materials, which makes the mausoleum seem larger and more ornate than it really is. Raphael had completed the entire pictorial design, including an altar panel, by 1513. The entire scheme for the chapel was not completed until a hundred years later, by the great Italian Baroque artist Gian Lorenzo Bernini.

In 1517, shortly after Raphael had completed his work on Bibbiena's living quarters, Chigi once again employed him in his villa, where he had already completed the fresco depicting Galatea (ill. 76). Before that, he had planned a small building for Chigi. Like Bibbiena, Chigi wanted a special room in which classical motifs were to feature. For this new project Raphael's experience as an architect was very useful. Once again, the decorative work was undertaken mainly by his workshop. Raphael devised the underlying structural concept from the room's architectural function. According to his commission, he was to decorate the large entrance loggia, which communicates between the living-room and garden outside, with scenes from

the myth of Cupid and Psyche (ill. 135). Raphael approached the highly individual character of the space by treating the roofed building, which is in fact part of the main building, as an open pergola.

He developed its structure out of the existing wall divisions, and covered them with magnificent, rampant garlands of fruit. Treating the room as a pergola, he designed the two large ceiling pictures that simulate tapestries stretched across the roof. These huge awnings were painted so ingeniously that we can see the straps holding them in place and the scalloped edges they create by stretching the material.

The cycle of pictures appears only on the ceiling. Raphael designed a view out onto a brilliant blue sky, in which half-naked figures – either hovering or standing on clouds – merge into an erotically charged scene. The simulated tapestries depict two scenes: the gods deciding to subject Psyche to various tests, and Psyche holding a magnificent banquet to celebrate her acceptance into the circle of the Immortals. Both scenes were no doubt meant to impress upon guests the cultural attainments of the household. Despite a strong erotic charge, the cycle was meant as an example of virtuous womanhood (ill. 136).

The most elaborate project to occupy Raphael during the last years of his life was an architectural one: planning the Medici residence, now known as the Villa Madama, on the slope of the Monte Mario in northern Rome. His plan was ambitious, for he was to design a villa worthy of classical antiquity. As well as the ruins of ancient buildings like Hadrian's Villa in Tivoli, Raphael studied classical descriptions of villas, such as those found in Pliny the Younger and in Vitruvius's

133 *The Sibyls*, ca. 1511–1513
Fresco, width at base 615 cm
Sant'Agostino, Rome

The Sibyls sit above the arch that leads to the second private chapel of the banker Chigi. The turning movements of the bodies are reminiscent of those of *The Virtues* (ill. 69) in the Stanza della Segnatura, but the coloration suggests they were painted at a later date.

134 (opposite) Cupola of the Chigi Chapel,
ca. 1511–1516
Santa Maria del Popolo, Rome

In 1508 Julius II gave the title of the chapel to the banker Chigi, who commissioned Raphael to turn it into a family mausoleum. By 1513 the plans were ready and the renovation was completed by late 1515 or early 1516. The Venetian painter Luigi da Pace later completed the mosaics on the cupola using Raphael's cartoon.

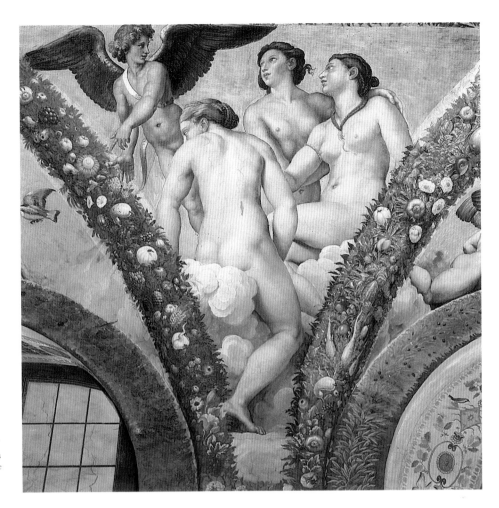

136 (right) *Cupid and the Three Graces*, ca. 1517–1519
Fresco
Loggia of Psyche, Villa della Farnesina, Rome

It was said that only in the presence of the Three Graces
could a young man recognize the charms of his beloved.
Cupid is looking at the Graces and pointing with his left
hand, not at Psyche, but at the loggia itself, the Chigis'
own world. This is no doubt meant to refer to the lady of
the house. Pope Leo X liked Giovanni da Udine's garlands
so much that he commissioned the painter to decorate the
first floor of the loggia in the Vatican with similar floral
motifs.

135 (opposite) Loggia of Psyche, ca. 1517–1519
19.3 m x 7.5 m in outline
Villa della Farnesina, Rome

The myth of Cupid and Psyche is depicted on the loggia
of Agostino Chigi's villa. Cupid fell in love with the
daughter of a king, but had to remain unrecognized by
her, and so came to her only at night. After Psyche had
undergone many difficult trials, Zeus made her immortal,
and allowed her to marry Cupid. The unusual subject
seems to be a reference to the much yearned for marriage
between Chigi and Francesca Ordeaschi, with whom he
already had four children. The ceremony took place on 28
August 1519.

architectural textbook. He also had ruins surveyed,
including the Marcellus Theater in Rome. Raphael
worked with a team of architects which included,
among others, Antonio da Sangallo the Younger, whose
now deceased uncle had taken charge, together with
Raphael, of the rebuilding work on St. Peter's in 1514.
Raphael's design for the Villa Madama promised to fulfil
the high expectations it had raised. He began work on
the sketches in 1517, and they were finished by 1519
(ill. 137). By the time he died a year later, parts of the
villa had already been built. Giovanni da Udine and
Giulio Romano had already started work on decorating
rooms.

One of Raphael's main considerations when planning
the decoration of the Loggia of Psyche had been the
inter-penetration of interior and exterior space, of
building and surrounding nature. For the Villa
Madama, even the choice of the location – on the slope
of a hill high above the Tiber valley – was significant.
Around a circular inner courtyard, centrally located,
Raphael designed extensive, generously proportioned
grounds. Pathways and vistas formed the structure of the
plan. Loggias and terraces, as well as a large flight of stairs

and ponds were some of the architectural features he
employed. He also included an exedra in his plans, a
semicircular recess with seats for sitting in the open air,
a feature of Greek origin that had become a popular
feature of the villas and public squares of ancient Rome.
Raphael's notion of building an open-air theater in the
grounds of a private villa was something new in the
history of theater architecture. Not even half of the
project was in fact built (ills. 138, 139). What remains,
however, is enough to justify the view of his con-
temporaries that a great architect was lost when Raphael
died.

The Transfiguration (ill. 140) was the last work
Raphael painted himself, and more often than not it has
been described as his artistic legacy. It was commissioned
by Cardinal Giulio de' Medici, who was given the
Archbishopric of Narbonne in February 1515. On this
account, Giulio, the future Pope Clement VII, donated
two monumental altarpieces to the cathedral there. By
the end of 1516 at the latest he had commissioned *The
Transfiguration* from Raphael; he also commissioned the
Venetian artist, Sebastiano del Piombo, to paint *The
Raising of Lazarus* (ill. 141), which is now in the

137 Antonio da Sangallo the Younger
Plan of the Villa Madama,1519
Pen, ink and red chalk, several pages glued together,
60.1 x 125.8 cm
Galleria degli Uffizi, Gabinetto dei Disegni e delle Stampi,
Inv. 314A, Florence

Antonio da Sangallo the Younger, Bramante's assistant, was
appointed as second architect of St. Peter's at Raphael's request on 1
December 1516. He also worked on other projects with Raphael,
and drew the plans for them, as this one for the Villa Madama
shows. There is no detailed plan by Raphael's hand.

138 (bottom) Officina Modellisti Pietro Ballico
Model of the Villa Madama, ca. 1983
Wood
Bibliotheca Hertziana, Rome

This is a model reconstruction of the Villa Madama, which was
never completed. It is based on the parts that were built, on the
architectural drawings by Antonio da Sangallo the Younger, and
any other sketches that were available. However, it does not
show how the landscape was to be made into an integral part of
the complex. The scale is about 1:37.

139 *Design for Theater Scenery,* ca. 1519
Pen and ink wash, highlighted in white chalk,
62.5 x 29 cm
Galleria degli Uffizi, Gabinetto dei Disegni e delle Stampe,
Inv. 560A, Florence

Architectural scenery was not usually part of stage sets until the
16th century. This drawing, which is an early example of its
kind, has been linked with Raphael's work on the scenery for
Ariosto's play, "I Suppositi," in 1519.

National Gallery, London. This double commission resulted in an artistic contest, in which Sebastiano's friend, Michelangelo, also became embroiled – Sebastiano sent the preparatory drawings to him in Florence.

Del Piombo's subject, the raising of Lazarus, was suitable for a dramatic historical painting in the monumental style of Michelangelo. Raphael's task, by contrast, was to depict the revelation of Christ's double nature as a human and divine, a Christological subject which did not lend itself to a dramatic portrayal. He solved this problem by means of an iconographic innovation. In a single pictorial event he was able to combine two unrelated Bible stories, which, considering Christ's double nature, was entirely apt. The first was Christ's Transfiguration, which he depicted as a vision, an approach often used before. The second was the story (related in Matthew 17:15) of the "lunatic" boy who was

healed by Jesus: here Raphael was able to use his skills in dramatic portrayal to the full (ill. 144).

The painting's various levels of meaning, as interpreted by the art historian Rudolf Preimesberger, can only be touched upon here. The healing of the sick boy should be read as a tribute to the donors, the Medici, whose name means "doctors". Christ is in fact the boy's healer, so here a direct link with the painting's donor is created. The name Medici also stood for deliverance from the Turks, who threatened all Christendom. The reflection of a small crescent moon in the bottom left-hand corner of the picture is not merely an allusion to the child's lunacy, but is also a symbol of the Ottomans. Raphael introduced another specific reference to the commission by depicting Justus and Pastor, the most important patron saints of Narbonne Cathedral, who can be interpreted as witnesses of the Transfiguration.

As soon as they entered the church, believers were

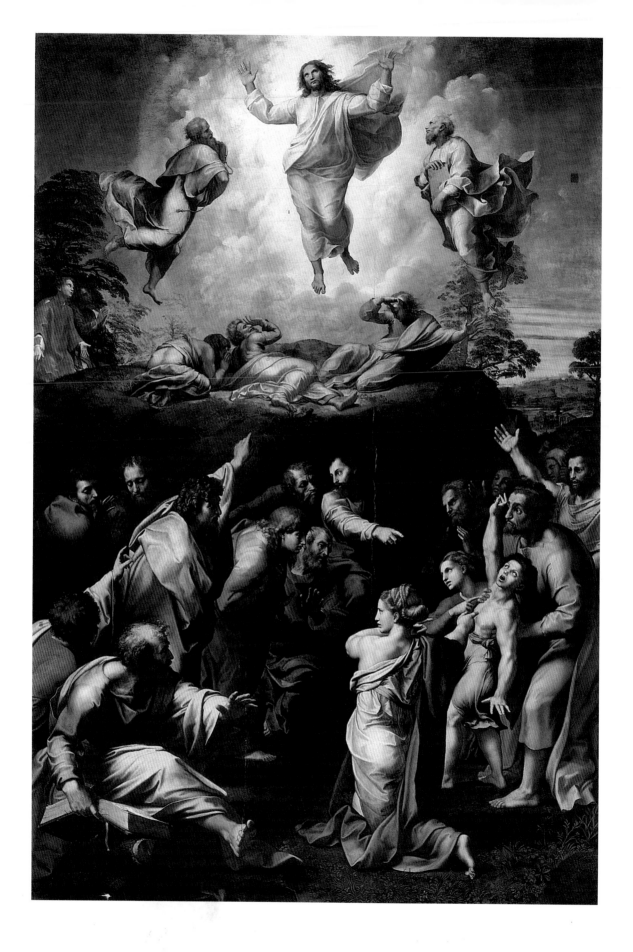

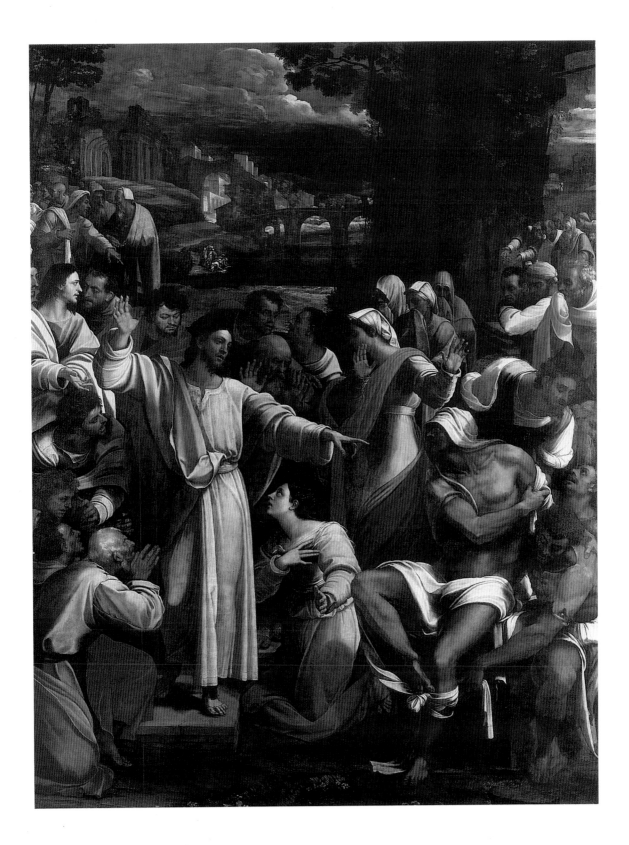

142 (right) *The Transfiguration* (detail ill. 140),
ca. 1519/20

Jesus Christ in shown against a bright light that strongly
emphasizes the outline of His figure. Its brightness creates
a striking effect when seen from a distance. The
outstretched arms recall the shape of the Cross on which
He died, and yet the figure is not stiff but elegant in
appearance.

140 (previous double page, left) *The Transfiguration*,
ca. 1519/20
Panel, 405 x 278 cm
Vaticano, Pinacoteca Apostolica Vaticana, Rome

Two scenes are incorporated into this altarpiece, which
was the last work painted entirely by Raphael himself.
The upper zone shows Christ's Transfiguration on Mount
Tabor. The prophets Moses and Elijah are hovering next
to him, while the Apostles who witnessed the event are
lying on the ground dazzled by the radiant figure. Below
there is a scene from Jesus' life, the healing of the
possessed lunatic boy.

141 (previous double page, right) Sebastiano del Piombo
The Raising of Lazarus, ca. 1517–1519
Canvas, 381 x 287 cm
The National Gallery, London

Guilio de' Medici commissioned a Raising of Lazarus
from Sebastiano del Piombo to donate to the cathedral of
Narbonne, which owned a relic relating to the story. In
his Gospel, St. John divided the story of the miracle into
three parts: Jesus bids the people take the stone from the
tomb, He tells Lazarus to rise, and then He tells him to
unbind his shroud. Sebastiano shows the third of these
commands.

meant to see the vision from afar and understand it as
an ever-recurring event. With this in view, Raphael
conceived the upper half of the composition as a light-
filled, brilliantly illuminated space, in which the wind
is dramatically blowing the figures' garments. He
emphasized the everlasting nature of the scene by
placing the main figure at the center of a circular
composition.

Only the person who was able to step right up to the
picture – in other words the priest celebrating the Mass
– would directly confront the second scene, below. The
gesture of the figure sitting in the bottom left-hand
corner is there for the benefit of the viewer and demands
his or her whole attention (ill. 143). The direction in
which characters are looking and gesturing lead the eye
through a scene bathed in cool moonlight and made
dramatic by strong *chiaroscuro*. At the center of this
asymmetrical composition stands the boy, who has just
been seized by terrible convulsions. Even though the boy
is unattractive, Raphael was able to make even his figure
fascinating (ill. 144). He is pointing towards Jesus
Christ, who redeems everyone from suffering.

Raphael died unexpectedly on Good Friday: 6 April
1520. Apart from a few touches, *The Transfiguration* was
complete. Vasari wrote: "He was laid out in the room
where he last worked, and at his head hung his painting
of the transfigured Christ, which he had completed for
Cardinal de' Medici. The contrast between the picture,
which was so full of life, and the dead body filled
everyone who saw it with bitter pain." This scene has
undoubtedly persuaded people to celebrate the painting
as Raphael's legacy. Giulio de' Medici did not send the
panel to Narbonne, but kept it in Rome and donated it
to the church of San Pietro in Montorio. There it could
serve to instruct other artists, and it was admired by both
Mannerists as well as Roman painters of the Baroque.
Later generations of artists not only admired this work
but saw in most of Raphael's compositions promising
models for the future, from which they could imitate,
vary, or borrow motifs. It was as if they all agreed with
Vasari when he said: "And thus, those who follow
Raphael will win fame in this world, and, if they follow
his exemplary mode of life, will be rewarded in heaven."

143 *The Transfiguration* (detail ill. 140), ca. 1519/20

Distressed by the sight of the child twisting in
convulsions, the Apostle turns away with a gesture of
heartfelt compassion. His hand and foot seem to protrude
from the front edge of the picture, drawing the onlooker
into the scene as a witness to the event.

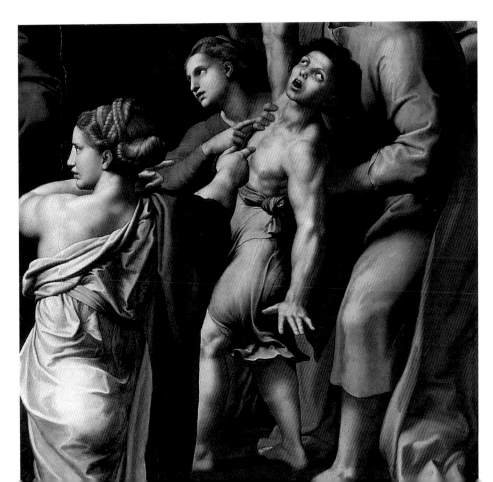

144 *The Transfiguration* (detail ill. 140), ca. 1519/20

This boy is the embodiment of the aesthetic paradox that
the ugly can be portrayed in a beautiful way. The
humanist Giovio admired the figure for the way in which
the physical movement and the fixed stare show the exact
physical and mental state of the sick child.

CHRONOLOGY

1483 6 April, Good Friday. Raphael is born, the son of the painter Giovanni Santi di Pietro and his wife Màgia di Battista di Nicola Ciarla.

1494 1 August. Death of father.

1500 10 December. Commission for the altarpiece *St. Nicholas of Tolentino* goes to Raphael and the older artist Evangelista da Pian di Meleto. Raphael is named *magister* (master) in the contract, and his name appears before that of his partner.

1501 13 September "Magister Rafael Johannis Santis de Urbino et Vangelista Andree de Piano Meleti" have completed the *St. Nicholas of Tolentino* altarpiece and have received payment.

1501–1503 Commission from the Poor Clares of Monteluce in Perugia for a Coronation of the Virgin.

1503 Documents dated 19 January and 8 March show that Raphael was in Perugia.

1504 A letter of recommendation from Giovanna Felicia Feltria della Rovere to *gonfaloniere* Sonderini in Florence, dated 1 October, announces Raphael's move to Florence.

1505 On 12 December Raphael and Roberto di Giovanni di Marco decide to paint a Coronation of the Virgin for the Poor Clares of Monteluce, in the style of the Ghirlandaio in San Giralamo di Narni. In the contract Raphael mentions his possible places of residence as Perugia, Assisi, Gubbio, Rome, Siena, Florence, Urbino, Venice, and "any other place." On 23 December Raphael receives a first payment of 30 ducats for the *Coronation of the Virgin* in Monteluce.

1509 A document dated 13 January shows that Raphael was in Rome. On 4 October he was given the honorary title of "Brief Writer."

1511 A letter from Julius II shows he wanted Raphael to include a portrait of Federico Gonzaga in a fresco in the Vatican Palace.

1512 The date MDXII is inscribed beneath the fresco *The Mass at Bolsena* in the Stanza di Eliodoro. A letter of 24 May indicates that Isabella d'Este wanted Raphael to paint a waist-length portrait of Federico Gonzaga in armor.

1513 Julius II dies on 21 February. On 11 March Giovanni de' Medici is chosen as his successor, taking the name Leo X. On 7 July Raphael receives a first payment of 50 ducats from the treasurer of the new pope.

1514 Bramante dies. On 1 April Raphael is provisionally appointed chief architect of St. Peter's with an annual salary of 300 ducats. On 1 July the official appointment as Bramante's successor is issued by a Papal Brief. The letter to Castiglione in which Raphael declares that he believes the ideal beauty, composed of many beautiful parts, is superior to natural beauty, also dates from this year.

1515 The tapestry cartoons for the Sistine Chapel are mentioned for the first time in a payment made on 15 June. On 27 August, Raphael was appointed Director of Antiquities (*Commissario dell'Antichità*) of Rome.

1516 The *stufetta* is finished on 20 June. The contract for the *Coronation of the Virgin* for Monteluce is renewed on 21 June. There is a record for the final payment for the tapestry cartoons dated 20 December.

1517 Castiglione composes two sonnets on his portrait by Raphael. On 19 January Sellaio reports to Michelangelo that Raphael has received the commission for *The Transfiguration* and that Sebastiano del Piombo has also received one for *The Raising of Lazarus*. Raphael had almost finished the frescoes in the Stanza dell'Incendio, according to a letter containing the commission for a Triumph of Bacchus from the Duke of Ferrara.

1518 Sellaio tells Michaelangelo on 1 January that the Loggia of Psyche in the Villa Farnesina is completed. A portrait of Lorenzo de' Medici by Raphael is mentioned in letters. Payment for the Loggias in the Vatican. On 27 May the *Holy Family* and *St. Michael* for Francis I are ready. On 2 July Sebastiano del Piombo tells Michelangelo that Raphael has not yet begun *The Transfiguration*.

1519 On the 16 June Castiglione mentions that the Vatican Loggias are finished.

1520 Between March and October payments for scaffolding in the Sala di Costantino are made.
Raphael dies on 6 April, Good Friday.

GLOSSARY

aerial perspective, a way of suggesting the far distance in a landscape by using paler colors (sometimes tinged with blue), less pronounced tones, and vaguer forms.

allegory (Gk. *allegorein*, "say differently"), a work of art which represents some abstract quality or idea, either by means of a single figure (personification) or by grouping objects and figures together. In addition to the Christian allegories of the Middle Ages, Renaissance allegories make frequent allusions to Greek and Roman legends and literature.

altarpiece, a picture or sculpture that stands on or is set up behind an altar. Many altarpieces were very simple (a single panel painting), though some were huge and complex works, a few combining both painting and sculpture within a carved framework. From the 14th to 16th century, the altarpiece was one of the most important commissions in European art; it was through the altarpiece that some of the most decisive developments in painting and sculpture came about.

Apocrypha (Gk. "hidden things"), Jewish or Christian writings additional to the Old or New Testament which are not accepted as part of the Bible, though they continued to be read as holy texts. The adjective is **apocryphal.**

apse (Lat. *absis*, "arch, vault"), a semicircular projection, roofed with a half-dome, at the east end of a church behind the altar. Smaller subsidiary apses may be found around the choir or transepts. The adjective is **apsidal.**

architectonic (Gk. *arkhitektonikos*, "architectural"), relating to structure, design, or organization.

architrave (It. "chief beam"), in classical architecture, the main beam resting on the capitals of the columns (ie the lowest part of the entablature); the molding around a window or door.

attribute (Lat. *attributum*, "added"), a symbolic object which is conventionally used to identify a particular person, usually a saint. In the case of martyrs, it is usually the nature of their martyrdom.

Augustinians, in the Roman Catholic Church, a mendicant order founded in 1256 under the rule of St. Augustine (AD354–430). The order became widespread in the 14th and 15th centuries, renowned for its scholarship and teaching. Under the influence of humanism during the Renaissance, Augustinians played a leading role in seeking Church reform.

autograph (Gk. *auto graphos*, "written by oneself"), (of a painting) known to be entirely by a specific artist, ie not by assistants or imitators. The fact that a work is autograph does not necessarily mean it is signed – documentary evidence or a close analysis of style may determine authenticity.

Babylonian Captivity, the period (1309–1377) when the papacy, then under French domination, was in Avignon in France. The end of the Babylonian Captivity marked the beginning of the Great Schism (see below).

baldacchino or **baldachin,** (It. "brocade"), originally a textile canopy supported on poles and used for carrying dignitaries and relics. Later, an architectural canopy of stone or wood set over a high altar or bishop's throne.

balustrade, a rail supported by a row of small posts or open-work panels.

Book of Hours, a book of the prayers to be said at specific hours of the day. Books of Hours were usually for a lay person's private devotions, and many of them were richly illuminated.

cardinal virtues, during the Middle Ages and the Renaissance, there held to be several cardinal virtues, the first four derived from classical thought, the last three from Christianity: moderation or temperance (*temperentia*); courage or fortitude (*fortitudio*); wisdom (*prudentia*); justice (*justitia*); faith (*fides*); hope (*spes*); and charity or love (*caritas*).

cartoon (It. *cartone*, "pasteboard"), a full-scale preparatory drawing for a painting, tapestry, or fresco. In fresco painting, the design was transferred to the wall by making small holes along the contour lines and then powdering them with charcoal in order to leave an outline on the surface to be painted.

caryatid (Gk. "priestess"), a carved female figure used in architecture as a column to support an entablature.

chancel (Lat. *cancelli*, "lattice, screen"), in a church, the area around the altar for the clergy and choir (a part once screened off from the rest of the church).

cherub, pl. **cherubim** (Hebrew "angel"), an angel. In the medieval hierarchy of celestial being, one of the second order of angels. They are usually depicted as a winged child.

chiaroscuro (It. "light dark"), in painting, the modelling of form (the creation of a sense of three-dimensionality in objects) through the use of light and shade. The introduction of oil paints in the 15th century, replacing tempera, encouraged the development of chiaroscuro, for oil paint allowed a far greater range and control of tone. The term chiaroscuro is used in particular for the dramatic contrasts of light and dark introduced by Caravaggio. When the contrast of light and dark is strong, chiaroscuro becomes an important element of composition.

Christological, relating to the life and teachings of Jesus Christ.

contre-jour (Fr.), (of an image in a painting) shown standing in front of the light, back lit.

contrapposto (It. "placed opposite"), an asymmetrical pose in which the one part of the body is counter-balanced by another around the body's central axis. Ancient Greek sculptures developed contrapposto by creating figures who stand with their weight on one leg, the movement of the hips to one side being balanced by a counter movement of the torso. Contrapposto was revived during the Renaissance and frequently used by Mannerist artists, who developed a greater range of contrapposto poses.

copperplate engraving, a method of printing using a copper plate into which a design has been cut by a sharp instrument such as a burin; an engraving produced in this way. Invented in south west Germany in about 1440, the process is the second oldest graphic art after woodcut. In German art it was developed in particular by Schongauer and Dürer, and in Italian art by Pollaiuolo and Mantegna. Engravings were also an important way of disseminating new ideas and styles – those by Marcantoni Raimondi, for example, quickly spread a knowledge of Raphael's works throughout Europe.

craquelure (Fr.) the network of line cracks that appear on old paintings as the paint slowly shrinks.

cupola (Lat. *cupula*, "small vat"), in architecture, a small dome, usually one set on a much larger dome or on a roof; a semi-circular vault.

dado (It. "cube"), in architecture, the section between the base and the crown of a pedestal; the lower section of the wall of a room, decorated with panels.

Decretals (Lat. *decretalis*, "letters"), Papal decrees forming part of canon law in the early and medieval Church.

diptych (Gk. *diptukhos*, "folded twice"), a painting consisting of two panels hinged together. Usually an altarpiece, the diptych was common in the Middle Ages. They were often portable, the hinges allowing the two panels to be folded together.

en face (Fr. "face on"), of a sitter in a portrait, seen from the front, a frontal view.

ex voto (Lat. "because of a vow"), (of a gift) done in fulfillment of a vow, usually because a prayer has been answered.

famulus pl. *famuli* (Lat. "servant"), an attendant or assistant.

figura serpentinata (Lat. "serpentine figure"), a pose in which the human figure is twisted.

finial (Lat. *finis*, "end"), in architecture, a carved ornament crowning a gable, buttress, or pointed arch; they also appear on ornate furniture. They are characteristic of Gothic architecture.

Franciscans, a Roman Catholic order of mendicant friars founded by St. Francis of Assisi (given papal approval in 1223). Committed to charitable and missionary work, they stressed the veneration of the Holy Virgin, a fact that was highly significant in the development of images of the Madonna in Italian art. In time, the absolute poverty of the early Franciscans gave way to a far more relaxed view of property and wealth, and the Franciscans became some of the most important patrons of art in the early Renaissance.

fresco (It. "fresh"), wall painting technique in which pigments are applied to wet (fresh) plaster (*intonaco*). The pigments bind with the drying plaster to form a very durable image. Only a small area can be painted in a day, and these areas, drying to a slightly different tint, can in time be seen. Small amounts of retouching and detail work could be carried out on the dry plaster, a technique known as *a secco* fresco.

glaze, in painting, a thin, transparent layer of color painted over an earlier layer. Images built up through the application of glazes are far more luminous that those created with opaque color.

genii sing. *genius* (Lat.), in Roman mythology, a guardian spirit given to a person at birth; a protective spirit. In Renaissance art they are usually portrayed as child-like figures with wings.

gonfalonier (It. "standard bearer"), a high office in the government of several Italian Renaissance republics. The *gonfaloniere della giustizia* (the *gonfalonier* of justice) was a high official in the government of Florence.

Great Schism (Gk. "separation, split"), a split in the Roman Catholic Church, 1378–1417, when there were two lines of papal succession, one in Rome and one (of the so-called antipopes) in Avignon in France. The Great Schism was preceded by the so-called Babylonian Captivity, when the papacy resided in Avignon (see above).

grisaille (Fr. *gris*, "gray"), a painting done entirely in one color, usually gray. Grisaille paintings were often intended to imitate sculptures.

hatching, in a drawing, print or painting, a series of close parallel lines that create the effect of shadow, and therefore contour and three-dimensionality.

herm (Gk. the god Hermes), a bust of a classical god (usually Hermes) set on a quadrangular pillar that tapers towards the base. Herms, which had a religious significance in ancient Greece and Rome, became a familiar part of the repertoire of Late Renaissance decoration.

iconography (Gk. "description of images"), the systematic study and identification of the subject-matter and symbolism of art works, as opposed to their style; the set of symbolic forms on which a given work is based. Originally, the study and identification of classical portraits. Renaissance art drew heavily on two **iconographical** traditions: Christianity, and ancient Greek and Roman art, thought and literature.

illumination, manuscript decorations consisting of small, finely painted pictures (**miniatures**) or elaborately designed letters, painted in rich colors and sometimes with gold. Illumination flourished during the Middle Ages, dying out with the advent of printing.

Liber Pontificalis (Lat. "Pope's book"), a collection of papal biographies covering the period from the earliest popes until the 15th century.

lira da braccio (It.), a bowed musical instrument popular during the Renaissance, often used to accompany songs.

loggia (It.), a gallery or room open on one or more sides, its roof supported by columns. Loggias in Italian Renaissance buildings were generally on the upper levels. Renaissance loggias were also separate structures, often standing in markets and town squares, that could be used for public ceremonies.

lunette (Fr. "little moon"), in architecture, a semicircular space, such as that over a door or window or in a vaulted roof, that may contain a window, painting or sculptural decoration.

metal point, a method of drawing using a thin pointed rod of metal, usually silver, on parchment or paper that has been coated with an opaque white ground. Metal point produced a fine, grayish line. Developed in the Middle Ages it was popular throughout the Renaissance; it began to be replaced by graphite pencil in 17th century.

modello (It. "model"), a drawing of a proposed painting, often executed for the patron's approval. They were often highly finished and the design could be transferred to the canvas or wall by means of a grid drawn over the *modello* (**squared** *modello*) and then scaled up.

monochrome (Gk. *monokhromatos*, "one color"), painted in a single color; a painting executed in a single color.

mozzetta (It. *mozzare*, "to cut off"), a short cape covering only the shoulders, especially the short cape that forms part of the non-liturgical robes of bishops, cardinals and popes.

Order of the Garter, the highest order of knighthood in Britain, established by Edward III in 1348.

Pandects (Gk. *pandektes*, "all embracing"), a comprehensive digest of Roman civil laws, part of the *Corpus Juris Civilis* (Roman Civil Law).

Pantheon, temple built in Rome about 25 BC by Emperor Agrippa. Having a circular plan, and spanned by a single dome, it was one of the most distinctive and original buildings of ancient Rome.

paragone (It. "comparison"), the rivalry between painting and sculpture during the Renaissance as to which of the two arts was the more important. The debate this encouraged helped to define the nature and role of both arts.

parclose (Fr. *parclore*, "to close in"), a screen used to separate a shrine or chapel from the rest of a church.

pergola (It.), a passageway covered by a trellis on which climbing plants are grown.

peristyle (Gk.), a series of columns surrounding a building, particularly a temple; an inner court lined with columns.

perspective (Lat. *perspicere*, "to see through, see clearly"), the method of representing three-dimensional objects on a flat surface. Perspective gives a picture a sense of depth. The most important form of perspective in the Renaissance was **linear perspective** (first formulated by the architect Brunelleschi in the early 15th century), in which the real or suggested lines of objects converge on a vanishing point on the horizon, often in the middle of the composition (**centralized perspective**). The first artist to make a systematic use of linear perspective was Masaccio, and its principles were set out by the architect Alberti in a book published in 1436. The use of linear perspective had a profound effect on the development of Western art and remained unchallenged until the 20th century.

plinth (Gk. *plinthos*, "stone block"), in architecture, the block or slab on which a column, pedestal, or statue rests.

predella (It. "altar step"), a painting or carving placed beneath the main scenes or panels of an altarpiece, forming a kind of plinth. Long and narrow, painted predellas usually depicted several scenes from a narrative.

Poor Clares, in the Roman Catholic Church, a contemplative order of nuns founded by St. Clare and St. Francis of Assisi about 1214. The order was one of the most austere.

provenance (Lat. *provenir*, "originate"), the origins of an art work; the history of a work's ownership since its creation. The study of a work's provenance is important in establishing authenticity.

putti sing. **putto** (It. "boys"), plump naked little boys, most commonly found in late Renaissance and Baroque works. They can be either sacred (angels) or secular (the attendants of Venus).

Restauratio Romae (Lat. "restoration of Rome"), an ambitious program of rebuilding and restoration work undertaken in Rome by Pope Julius II and Pope Leo X at the beginning of the 16th century, and continued by later popes. The intention was to make Rome, then the center and symbol of the Catholic faith, rival ancient Rome in its grandeur and power. The work involved – new buildings and programs of restoration, together with commissions for paintings and sculptures – helped to make Rome the one of the most important art centers of the High Renaissance.

Sack of Rome, the plundering of Rome by the mercenaries of Emperor Charles V. These troops occupied the city from 6 May 1527 to 17 February 1528.

Sacra Conversazione, pl. *Sacre Conversazioni* (It. "holy conversation"), a representation of the Virgin and Child attended by saints. There is seldom a literal conversation depicted, though as the theme developed the interaction between the participants – expressed through gesture, glance and movement – greatly increased. The saints depicted are usually the saint the church or altar is dedicated to, local saints, or those chosen by the patron who commissioned the work.

sarcophagus, pl. **sarcophagi** (Gk. "flesh eating"), a coffin or tomb, made of stone, wood or terracotta, and sometimes (especially among the Greeks and Romans) carved with inscriptions and reliefs.

scorcio (It.) foreshortening. Among the best-known examples of extreme *scorcio* is Andrea Mantegna's painting *Lamentation Over the Dead Christ* (1464–1500).

sfumato (It. "misty, softened"), in painting, a very gradual transition from light to dark, a subtle modelling of forms that eliminates sharp contours. Made possible by the introduction of oil paints, *sfumato* was largely developed by Leonardo da Vinci.

Sibyls, in antiquity, women prophets. In Christian legend, Sibyls were though to have foretold the Birth, Passion and Resurrection of Christ, and so were the female counterparts of the male prophets of the Old Testament.

signoria (It. "lordship"), from the 13th to the 16th century, the governing body of some of the Italian city

states. They were usually small groups of influential men presided over by the head of the city's most important family.

simultaneous narration, the depiction of several episodes of a story in a single picture. A well-known Renaissance example is *The Tribute Money* by Masaccio, in the Brancacci Chapel in Florence, in which St. Peter is depicted three times in the same fresco.

stanza, pl *stanze* (It. "room"), room, chamber; the term is used of large-scale decorative schemes for rooms in Renaissance palaces and other imporatnt buildings. A well-known example is the Stanza della Segnatura in the Vatican, painted by Raphael.

Tabularium, public records office built in Rome 78 BC. Overlooking the Forum, the building (part of which still stands) is noted for its distinctive combination of arches and the classical orders. The building gave its name to a form of open gallery.

tempietto (It.), a small temple or temple-like building, usually round or polygonal. One of the best-known examples is Tempietto (San Pietro in Montorio) in Rome, designed by Bramante and completed in 1511.

Tiburtine Sibyl, a Sibyl of ancient Rome. According to Christian legend, Emperor Augustus had a vision while consulting the Tiburtine Sibyl in which he saw the Virgin Mary holding the Christ Child.

tondo, pl. **tondi** (It. "round"), a circular painting or relief sculpture. The tondo derives from classical medallions and was used in the Renaissance as a compositional device for creating an ideal visual harmony. It was particularly popular in Florence and was often used for depictions of the Madonna and Child.

Trajan's Column, a monumental column erected in Rome in AD113 to commemorate the deeds of Emperor Trajan. Around its entire length is carved a continuous spiral band of low relief sculptures depicting Trajan's exploits.

uomini famosi (It.), famous men. For the humanists of the Renaissance, the *uomini famosi* were often Greek or Roman generals, political figures, and philosophers.

varietà (It. "variety"), in Renaissance art theory, a work's richness of subject matter. Also *varietas* (Lat.)

Venus pudica (Lat. "modest Venus"), a depiction of the classical goddess Venus in which she holds one arm over her breasts and the other across her hips. The pose was popular with Renaissance artists.

SELECTED BIBLIOGRAPHY

Beck, James (ed.): Raphael before Rome. Studies in the History of Art, vol. 17, in: National Gallery of Art, 1986

Béguin, Sylvie: Un Nouveau Raphaël. Un ange du retable de Saint Nicolas de Tolentino, in: Revue du Louvre, Issue 31, 1982, pp. 99–115

Brown, David Alan: Raphael, Leonardo, and Perugino. Fame and Fortune in Florence, in: Leonardo, Michelangelo, and Raphael in Renaissance Florence from 1500 to 1508, ed. by Serafina Hager, Washington 1992, pp. 29–53

Dussler, Luitpold: Raphael. A Critical Catalogue, London, New York 1971

Frommel, Christoph Luitpold, Stefano Ray and Manfredo Tafuri: Raffaello architetto, Milan 1984

Frommel, Christoph Luitpold and Matthias Winner (eds.): Raffaello a Roma, Il Convegno del 1983, Rome 1986

Golzio, Vincenzo: Raffaello nei documenti nelle testimonianze dei contemporanei e nella letteratura del suo secolo, Vatican City 1971

Knab, Eckart, Erwin Mitsch and Konrad Oberhuber: Raphael. Die Zeichnungen, Stuttgart 1983

Pagden Ferrino, Sylvia and Maria Antonietta Zancan: Raffaello. Catalogo completo dei dipinti, Florence 1989

Passavant, Gunter: Reflexe nordischer Graphik bei Raffael, Leonardo, Guilio Romano und Michelangelo, in: Mitteilungen des Kunsthistorischen Institutes in Florenz, vol. 27, 1983, pp. 193–222

Penny, Nicholas and Roger Jones: Raphael, New Haven, London 1983

Preimesberger, Rudolf: Tragische Motive in Raffaels "Transfiguration", in : Zeitschrift fur Kunstgeschichte, vol. 50, 1987, pp. 88–115

Shearman, John: Raphael's Cartoons in the Collection of Her Majesty the Queen and the Tapestries of the Sistine Chapel, London 1972

Shearman, John: The Vatican Stanze. Functions and Decorations, Proceedings of the British Academy, vol. 57, London 1972

Sonnenburg, Hubertus von: Raphael in der Alten Pinakothek, Munich 1983

Vasari, Giorgio: Vita de'più eccellenti architetti, pittori et scultori italiani, Florence 1568, ed. by Gaetano Milanesi, 9 vols., Florence 1878–1885

Winner, Matthias: Progetti ed esecuzione nella Stanza della Segnatura, in : Raffaello nell'appartamento di Guilio II. e Leone X., Milan 1993, pp. 247–291

PHOTOGRAPHIC CREDITS